America THE *Beautiful*

TEXAS

NORA CAMPBELL

FIREFLY BOOKS

A FIREFLY BOOK

Published by Firefly Books Ltd. 2010

Second printing

Publisher Cataloging-in-Publication Data (U.S.)

Campbell, Nora.
 Texas/ Nora Campbell.
[96] p. : col. photos. ; cm. (America the beautiful)
Summary: A book of captioned photographs that showcase the natural wonders,
dynamic cities, celebrated history and array of activities of Texas.
ISBN-13: 978-1-55407-594-2
ISBN-10: 1-55407-594-7
1. Texas – Pictorial works. I. America the beautiful. II. Title.
976.4 dc22 F387.C36 2010

Published in the United States by
Firefly Books (U.S.) Inc.
P.O. Box 1338, Ellicott Station
Buffalo, New York 14205

Published in Canada by
Firefly Books Ltd.
50 Staples Avenue, Unit 1
Richmond Hill, Ontario L4B 0A7

Cover and interior design: Kimberley Young

Printed in China

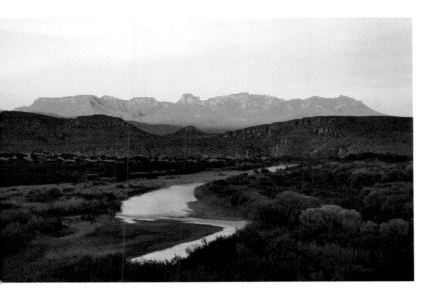

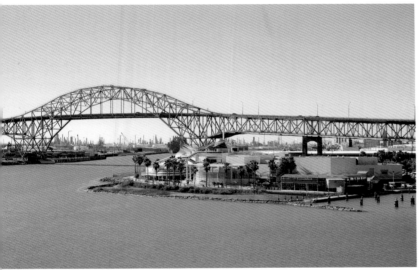

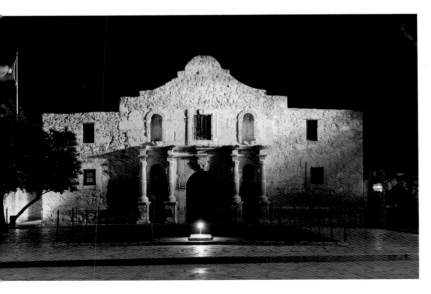

IT'S LIKE a whole other country. This declaration is the nationally recognized statement of Texan pride, and it's backed up by the state's dramatically rich history and spectacular landscapes.

Texas is famous for Stetsons and cowboy boots. Its long history at the center of the American cattle industry is still in evidence today, seen in its many rodeos and historic towns. But in the early 1900s, the discovery of oil initiated an economic boom. Since then, Texas has diversified with a growing base of industry, agriculture, energy, aerospace and biomedical sciences.

Texas is the country's second most populous state, and it is second in area only to Alaska. Twice the size of Germany, it is bordered by Mexico to the south, New Mexico to the west, Oklahoma to the north, Arkansas to the northeast, and Louisiana to the east. Within these borders there are seven official and diverse regions, each with its own distinctive appeal. The Gulf Coast offers beautiful sandy beaches. The South Texas Plains is rich in history, Mexican culture and unparalleled birding. Hill Country is famous for its endless fields of wildflowers and lush green regions. Big Bend Country offers rugged mountains and spectacular scenery. The Panhandle Plains, located in the northernmost region, has its own dramatic landscapes. The Prairies and Lakes region is diverse with exciting metropolitan areas, sports teams and historic towns. And in Piney Woods, there are no fewer than 12 state parks and four national forests. Following an introductory gallery, all seven regions are showcased in this book.

The term "Six Flags over Texas" comes from the several nations that, at various times, controlled its territory. March 2, 1836, marks the beginning of Texas's short history as an independent republic. In 1845 it joined the United States as the 28th state.

The name *Texas* originates from a Caddo Indian word meaning "Hello friend," a phrase that exemplifies the renowned hospitality of its citizens. The warm welcome visitors receive is equal only to the abundance of treasures that the state offers up. We hope you'll enjoy them as you travel the pages of *America the Beautiful – Texas*.

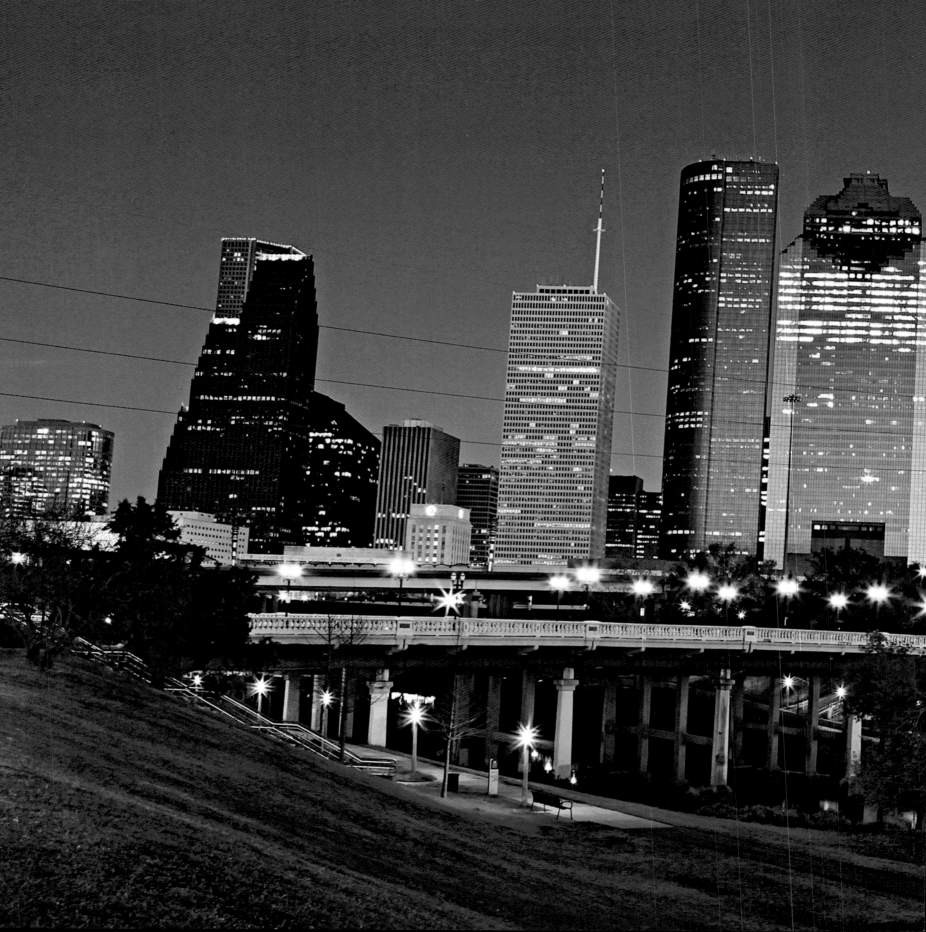

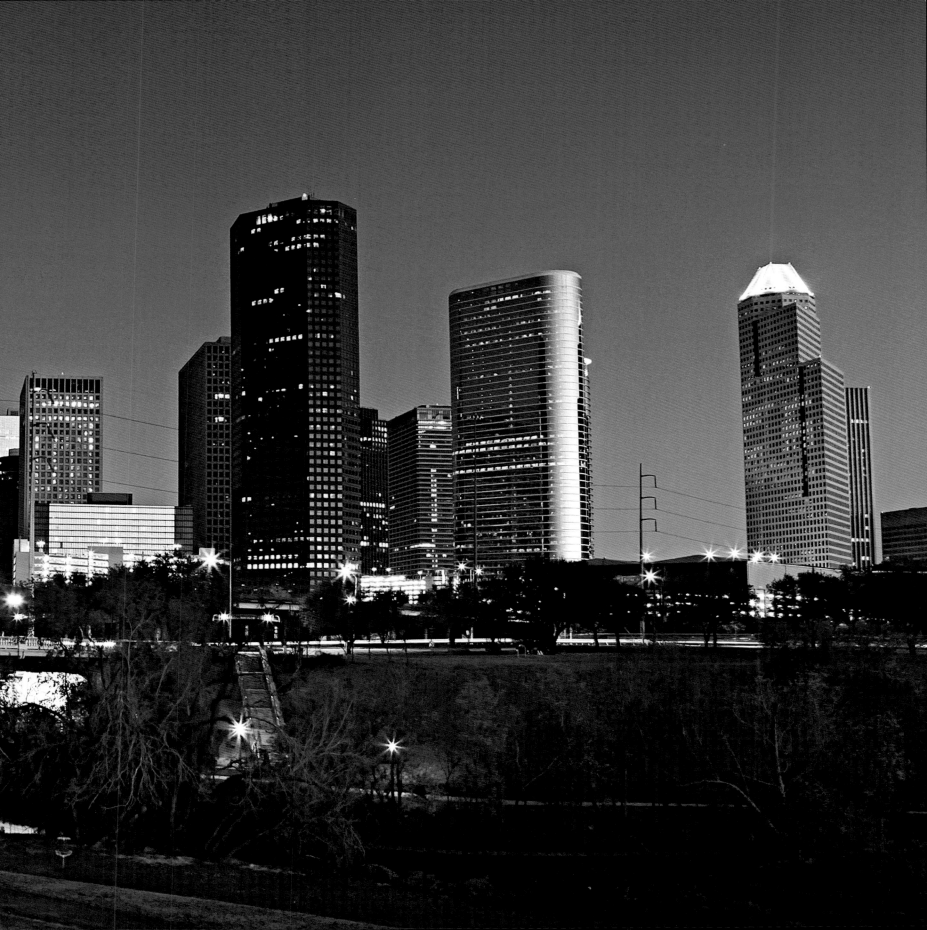

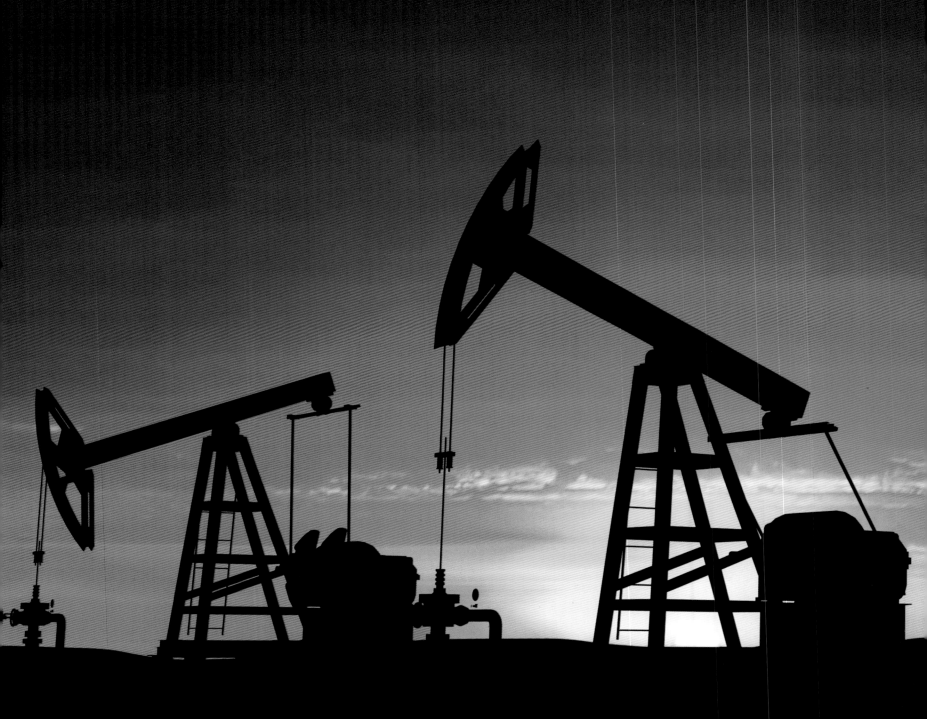

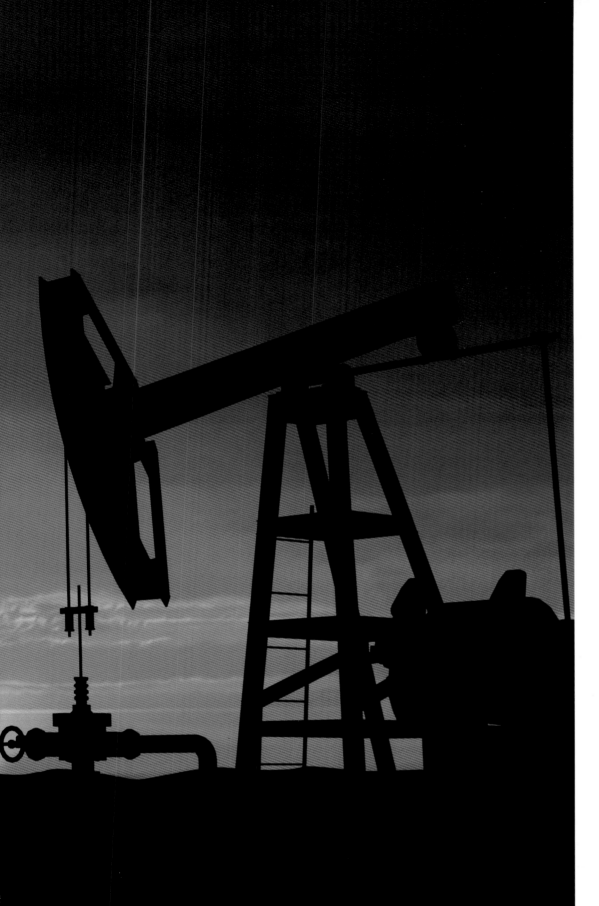

PREVIOUS PAGE: Named for General Sam Houston, the first president of the Republic of Texas, Houston has become an international center, as famous for its commercial hub as it is for its support of the arts. It has a world-class symphony and many excellent museums. It is the fourth most-populated city in the country.

A pumpjack, also known as a nodding donkey, horsehead, beam pump, grasshopper, or thirsty bird, is a common sight in west Texas. It is used to lift liquid out of the well if there is not enough bottom-hole pressure for it to flow all the way to the surface. Pumpjacks dot the landscape in many of the oil-rich areas.

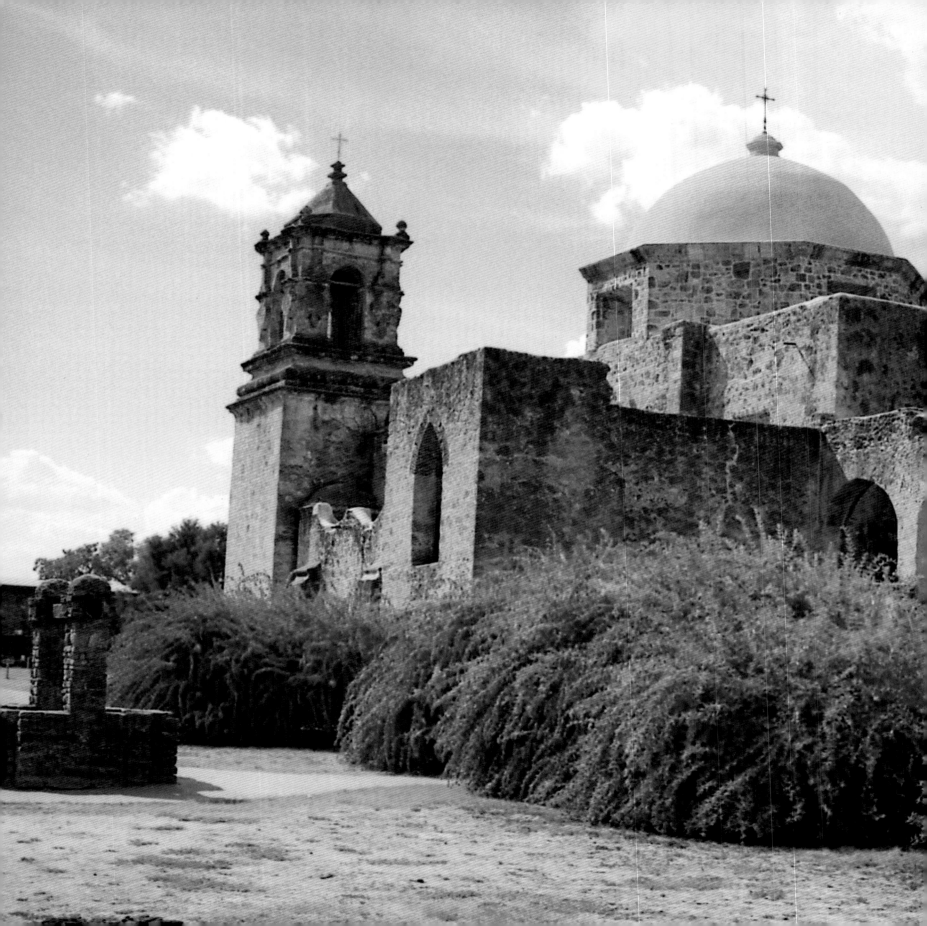

LEFT: In 1718, the first mission was established in San Antonio. Within 13 years, five missions were located along the city's river. Mission San José (y San Miguel de Aguayo) was the largest. It gained a reputation as a major social and cultural center and became known as the Queen of the Missions. This imposing complex of stone walls, bastions, granary and church was completed by 1782 and remains a magnificent structure.

BELOW: The Texas Longhorn is a distinctive breed of cattle whose horns can extend up to 7 feet from tip to tip. Originally imported from Spain in the early 1500s, these hardy cattle adapted to the harsh conditions of the open range. Today these majestic beasts stand as proud representatives of the Old West.

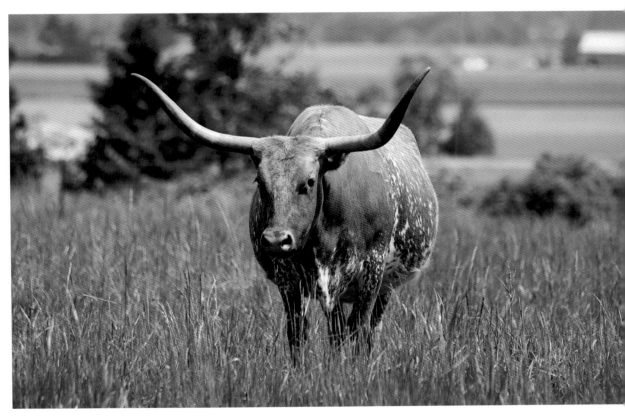

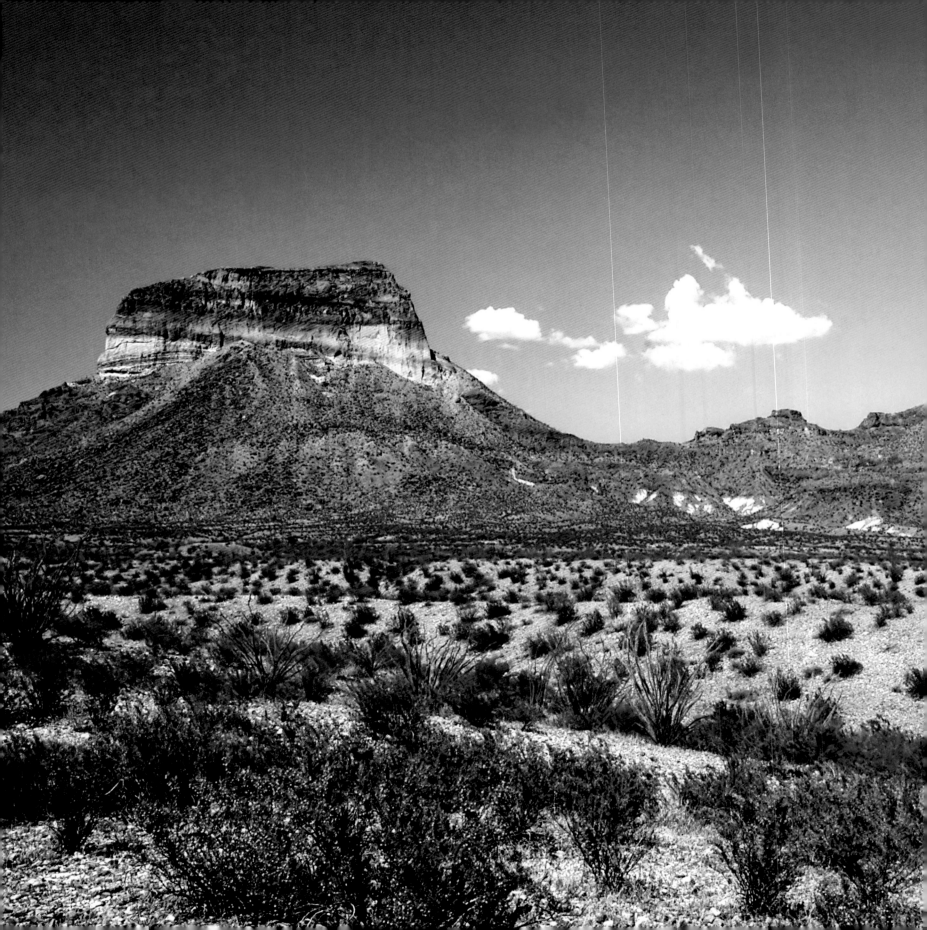

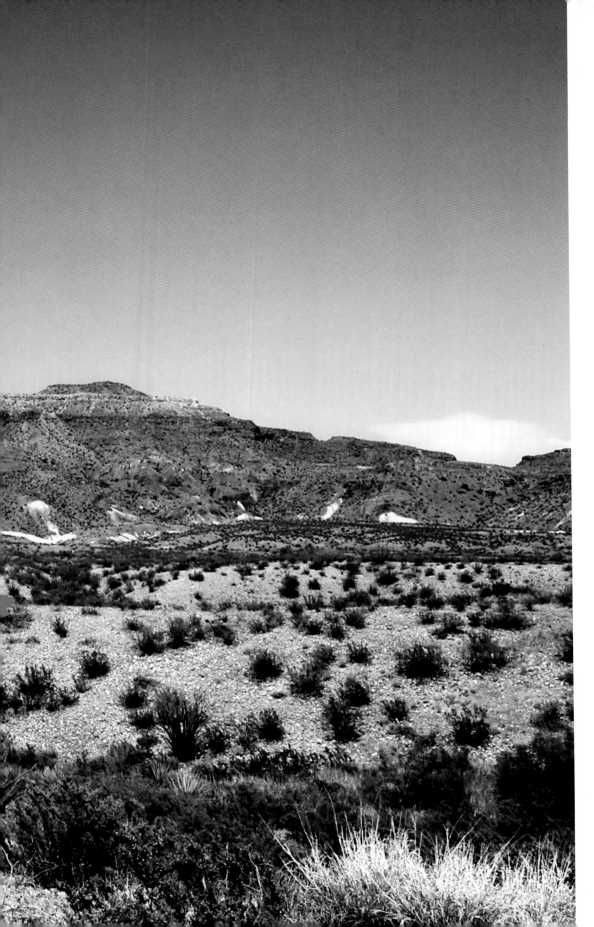

Big Bend is the only U.S. National Park to contain an entire mountain range. The Chisos Range features geographical extremes – deep serpentine rivers, sky-high mountains and breathtaking expanses of desert. Many indigenous plants, animals and birds are unique to this untamed territory in the southwest. Big Bend is a prime bird-watching destination. About 450 species of birds, many of which are unusual and endangered, are found here.

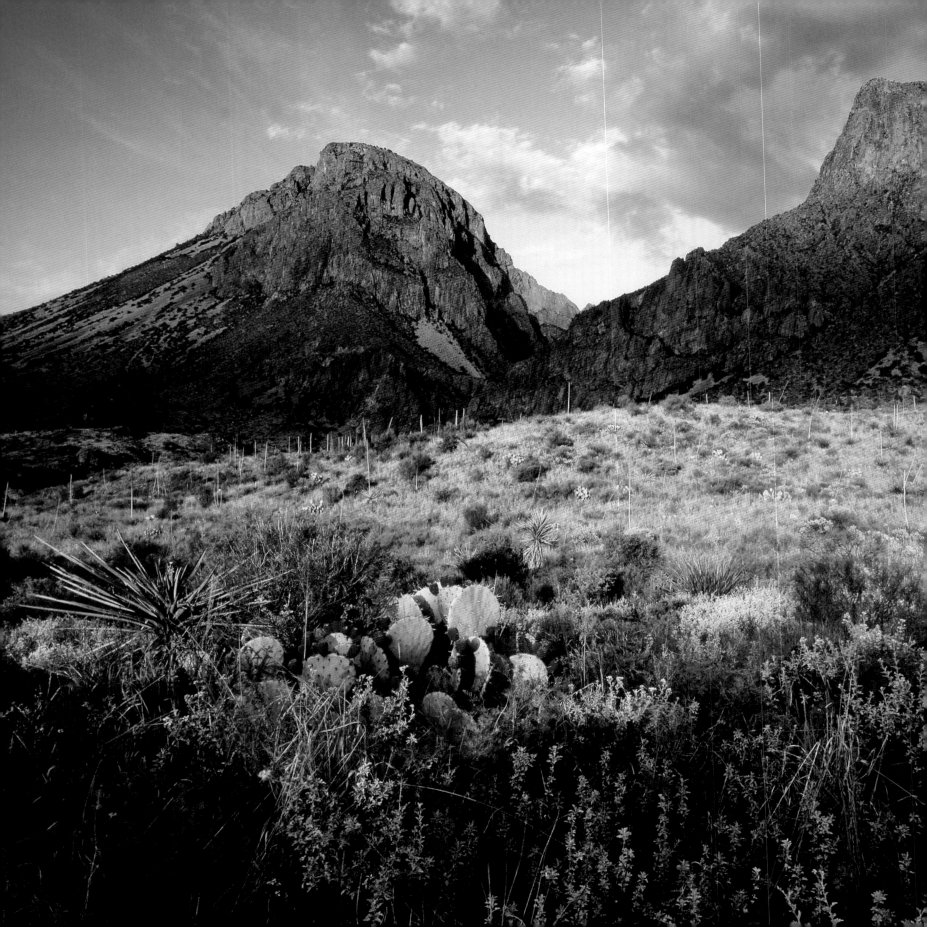

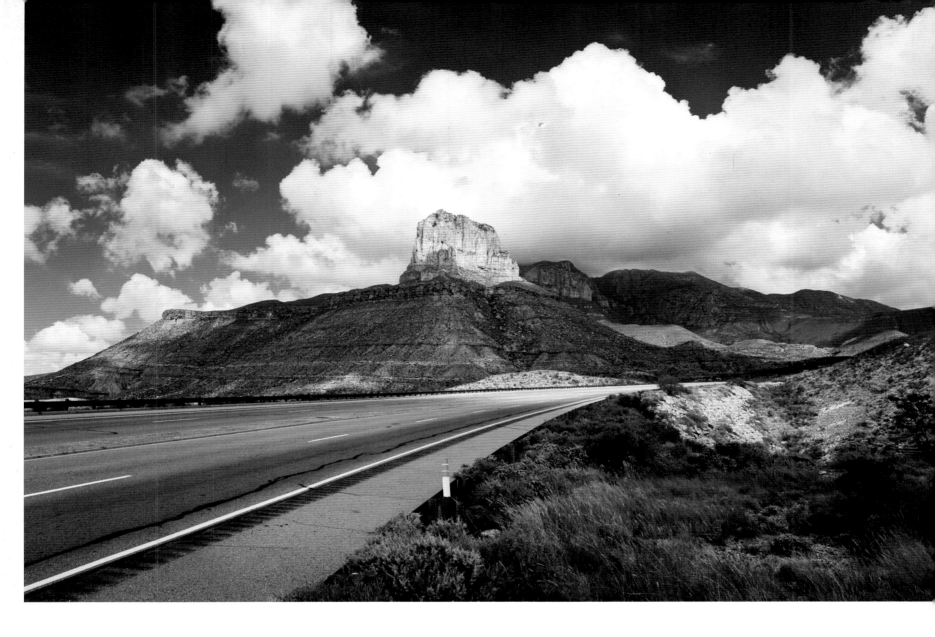

Seen from the south end of Guadalupe Mountains National Park in Culberson County, the austere and rugged peak called El Capitan dominates the landscape. It is an imposing guardian of this isolated range, rising unexpectedly from the surrounding Chihuahuan Desert.

OPPOSITE PAGE: Big Bend National Park is a rough and rugged region of sharp pinnacles and volcanic rock formations. Once covered by an inland sea, the dried sediment of sand and mud hardened, leaving enormous dramatically carved shapes in varying shades of yellow, orange and red, some towering to 7,800 feet above sea level.

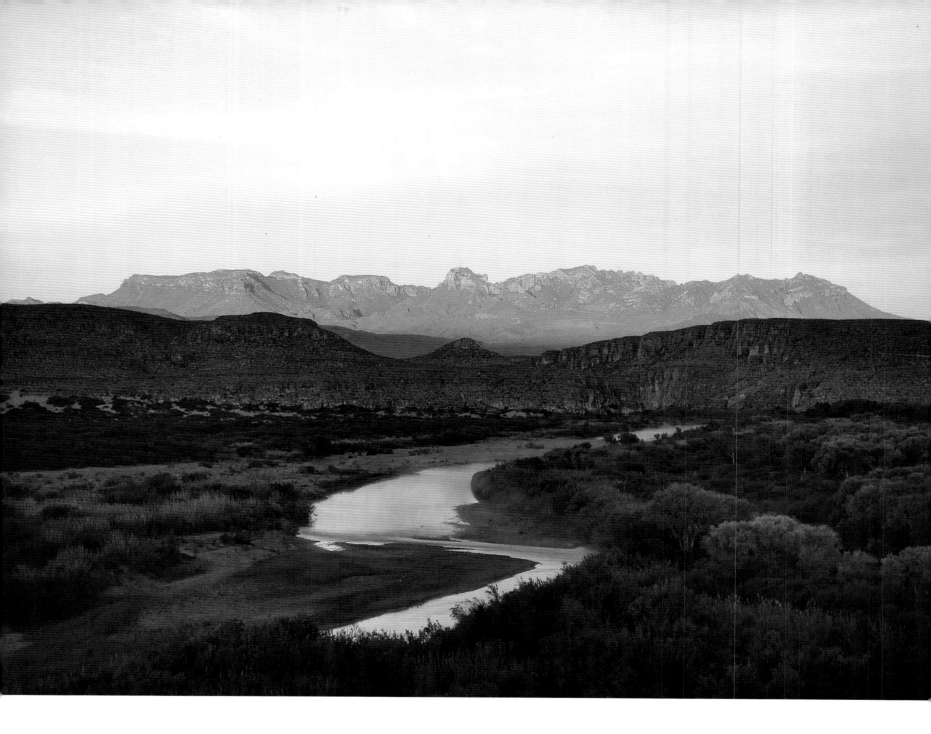

As the setting sun catches the imposing peaks of the Chisos Mountains, the Rio Grande meanders through the lowlands like a silk ribbon. The Rio Grande flows from its headwaters in the San Juan Mountains of southern Colorado for 1,885 miles to the Gulf of Mexico near Brownsville, Texas. For 1,250 miles, the Rio Grande is a natural boundary between the United States and Mexico.

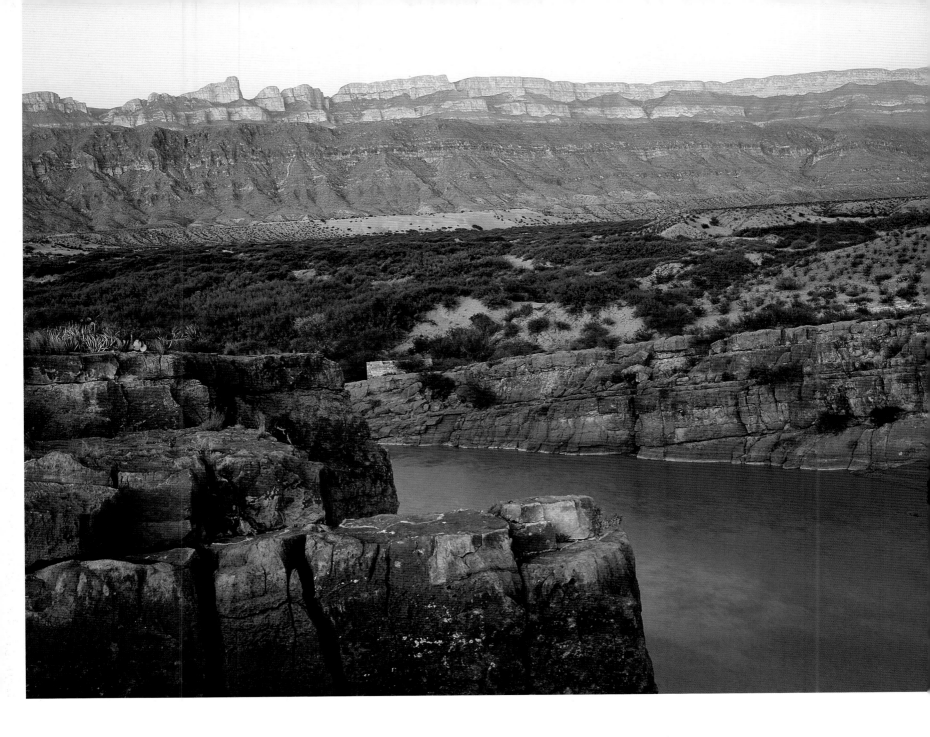

The Sierra Del Carmen mountain range emerges out of the Chihuahuan Desert to staggering heights. Bordering both Texas and Mexico, the cliffs are enhanced by the setting sun as it shines on the multi-colored rock face. Alternating bands of limestone and shale create definitive stripes in these majestic peaks.

The Rio Grande, or *Rio Bravo del Norte*, as it is known in Mexico, offers one of the most remote wilderness trips available in the United States. Flowing through the Texas–Mexico desert, the river offers spectacular views of majestic canyons, startlingly beautiful deserts, unique plant life, wild animals and rare birds.

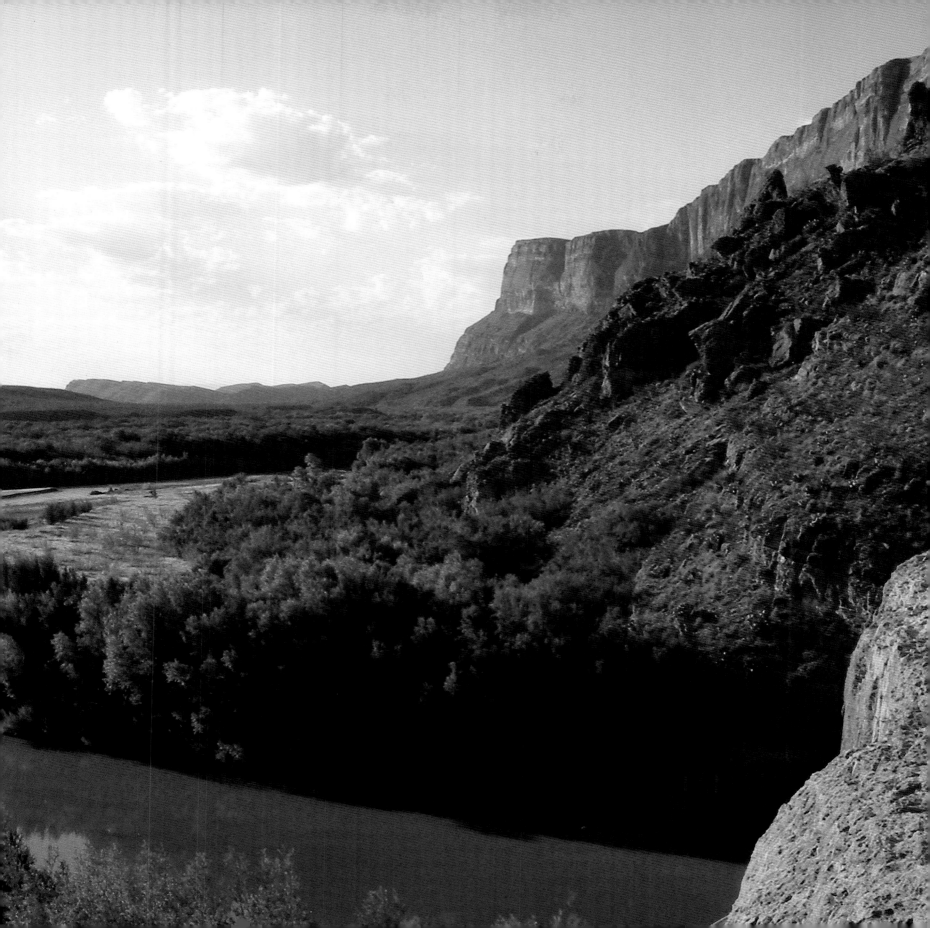

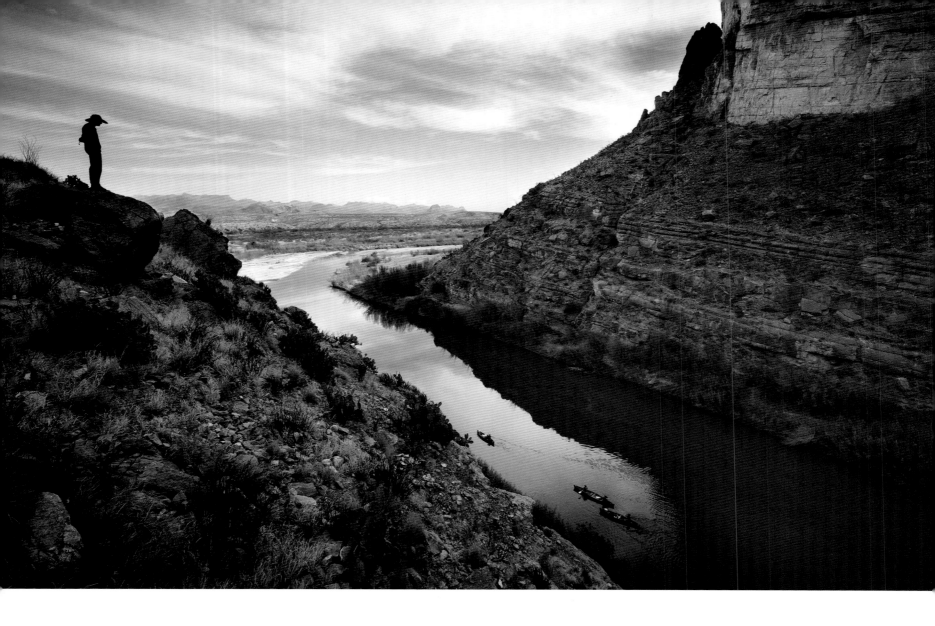

A man is silhouetted in the shadows of the mountainous walls of the Santa Elena Canyon. Over a thousand feet below, canoeists venture along the Rio Grande, no doubt humbled by the sheer majesty of the cliffs around them. For many miles upstream, the river is trapped by the high walls, eventually emerging into a wider valley at the small town of Lajitas.

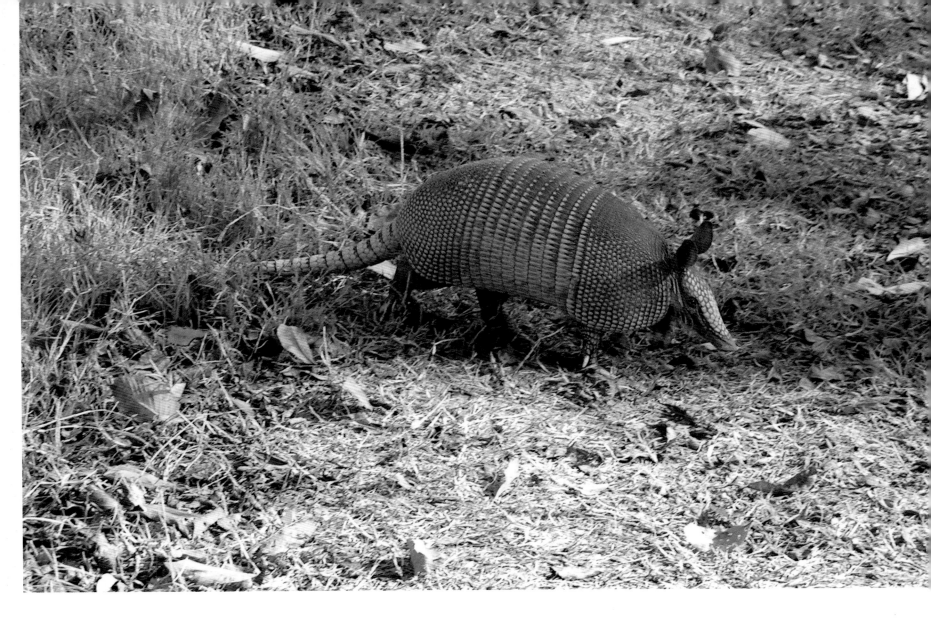

The nine-banded armadillo is the most common kind found in the south central states, particularly Texas. It is both a nocturnal and an omnivorous creature, living mostly on ants, beetles, small reptiles and amphibians.

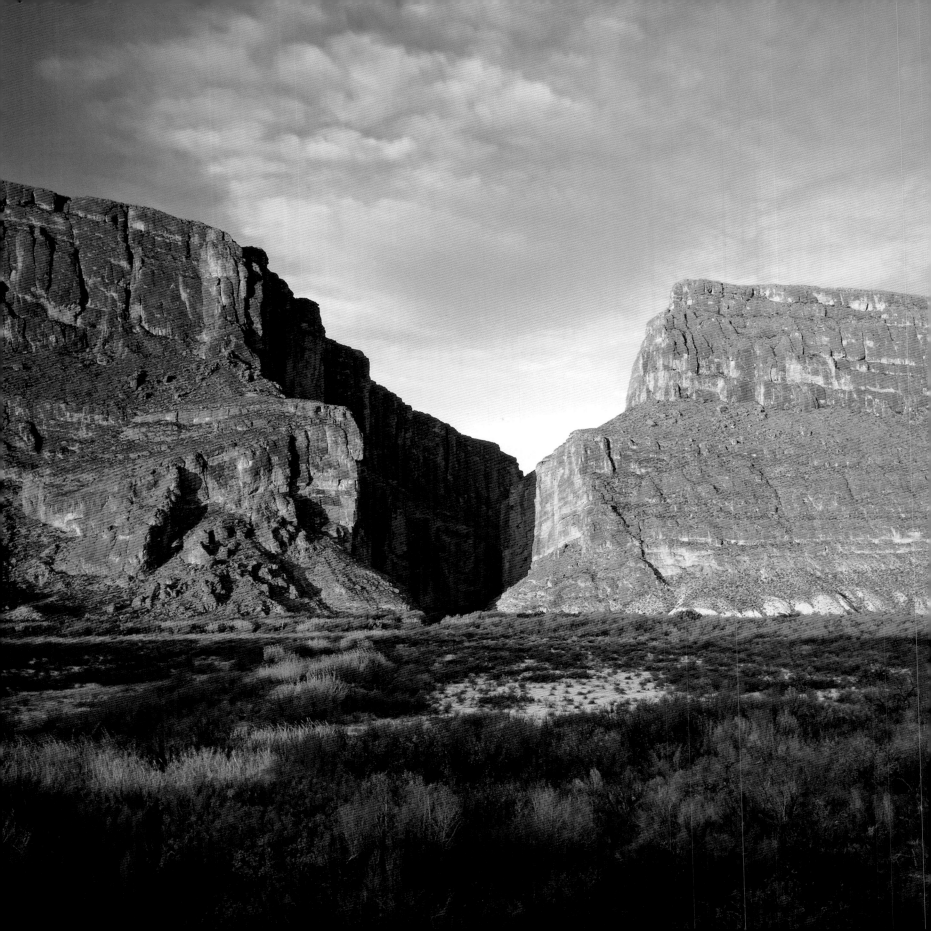

OPPOSITE PAGE: As you approach Santa Elena Canyon on the Rio Grande, you enter one of nature's most magnificent cathedrals. Santa Elena Canyon is the most impressive canyon in Big Bend National Park.

From this perspective, the massive cliffs face each other, with only a ribbon of water between them. The Rio Grande has carved through over 1,500 feet of sheer limestone rock to form the Santa Elena Canyon. Visitors can climb up a series of steep steps and hike along parts of the canyon wall.

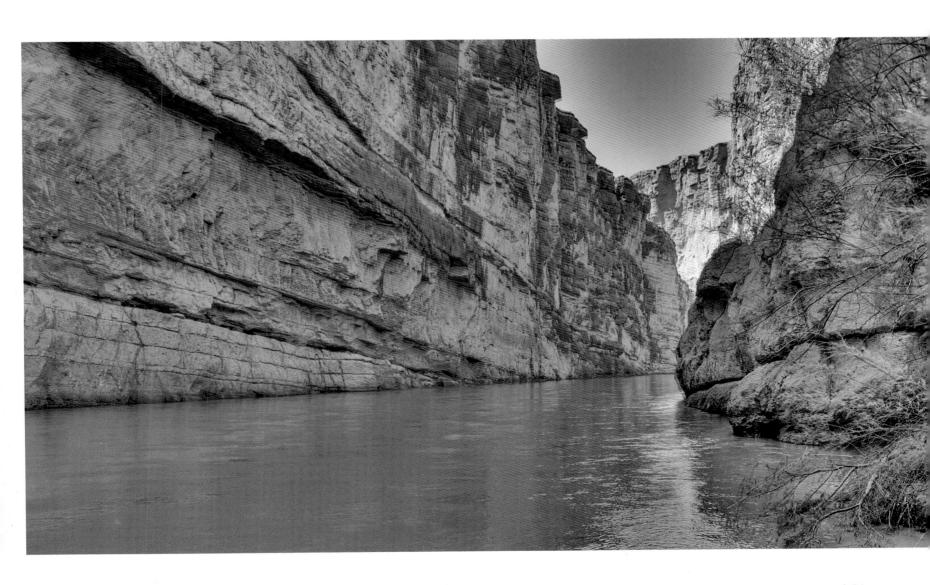

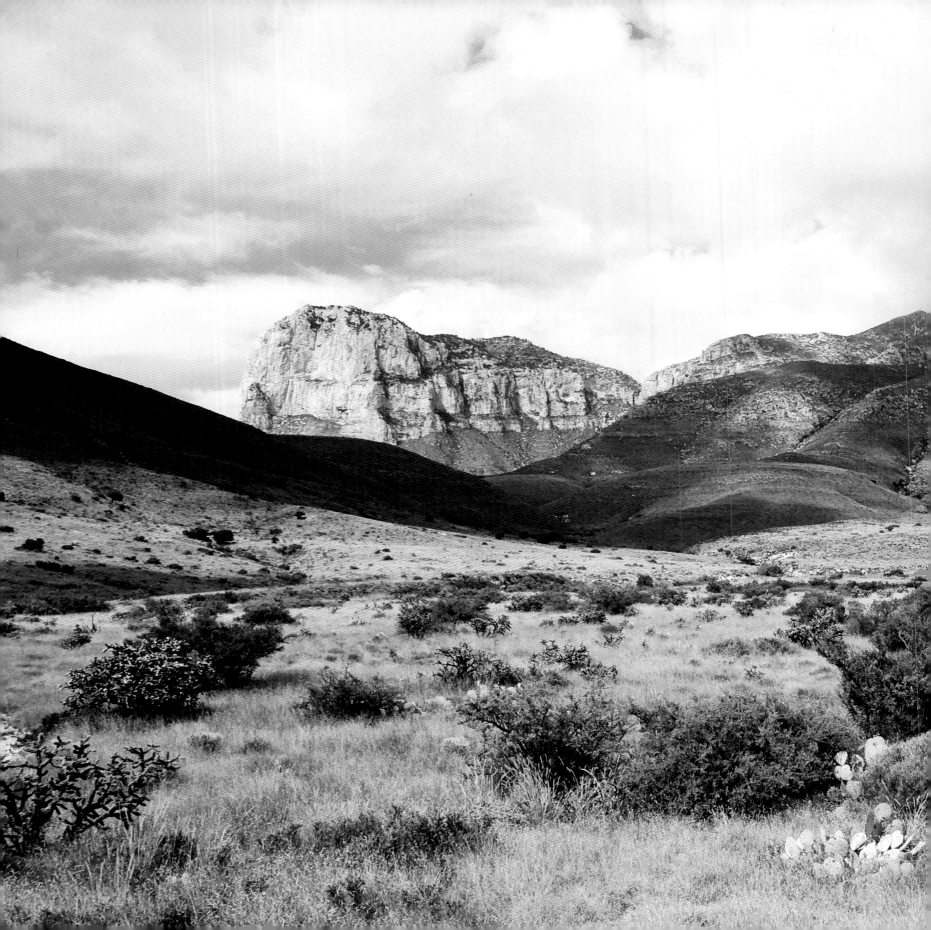

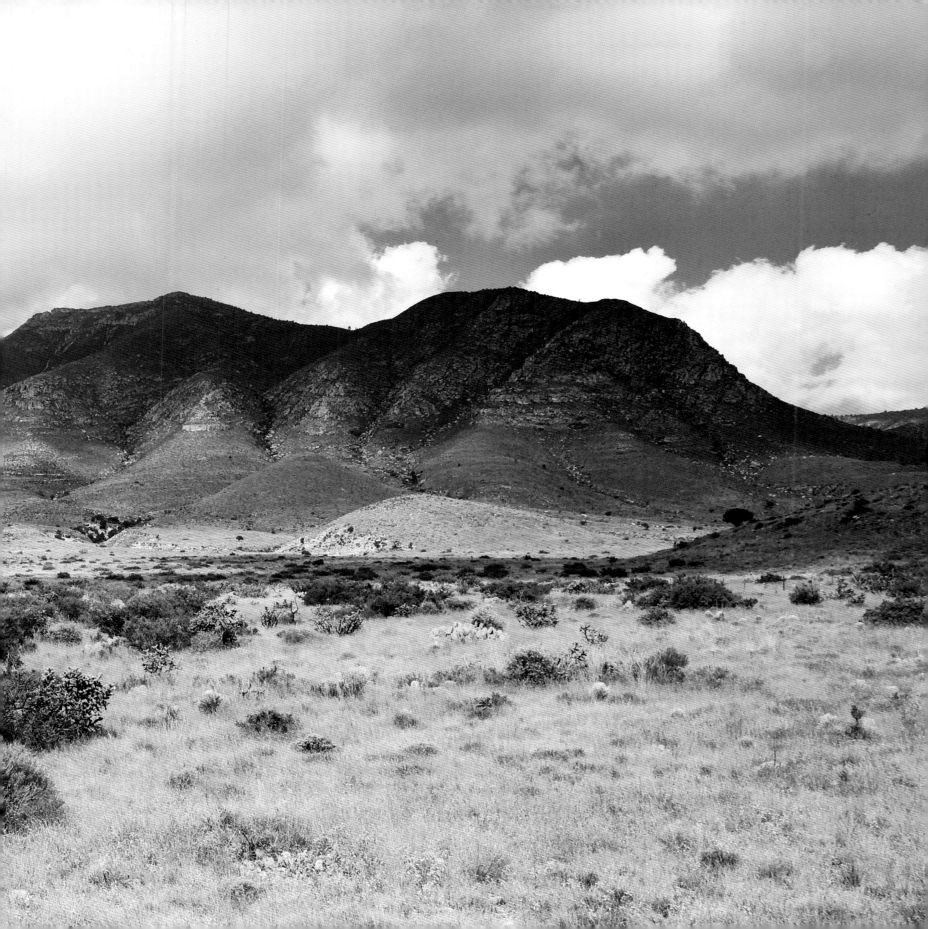

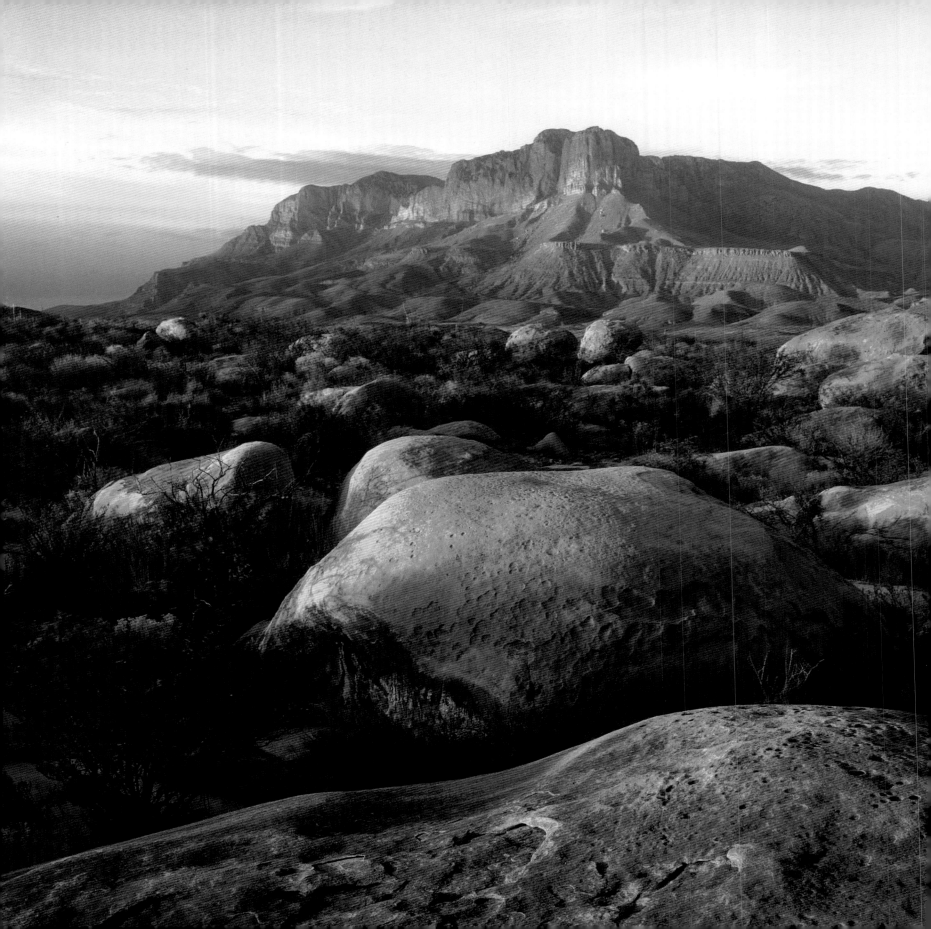

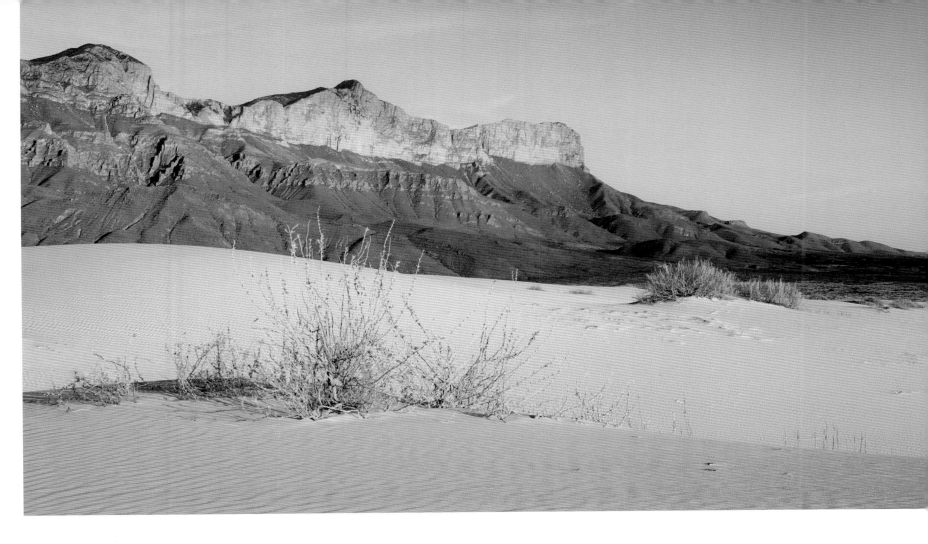

One of nature's most unusual wonders pushes up against the towering escarpment of the Guadalupe Mountains. Two million years ago, a series of shallow seas covered much of the area west of the mountains. Sediments and dissolved minerals washed into the seas from the mountain slopes. Today, for a distance of 45 miles, more than 5,000 acres of giant dunes made of crystallized sand continue to shift across the windblown desert.

OPPOSITE PAGE: The Capitan Reef Complex originated some 250 million years ago, leaving the horseshoe-shaped range that includes the Apache, Glass and Guadalupe Mountains. Over 400 miles long, the "reef" dominates the vast desert plains of west Texas with its massive cliffs and behemoth boulders.

PREVIOUS PAGE: The stark and foreboding Guadalupe Mountains rise out of the desert like a great gray beast. Guadalupe Mountains National Park is a craggy but spectacular wilderness. In contrast to the desert below, the vegetation is lush, with flora and fauna unique to the Southwest.

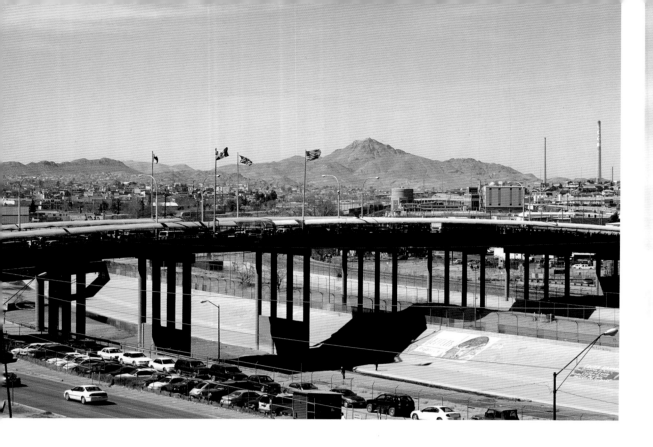

ABOVE: The first bridge to cross the Rio Grande at El Paso del Norte was built more than 250 years ago, from wood hauled all the way from Santa Fe. Today, three bridges connect El Paso with its Mexican border city, Ciudad Juárez.

RIGHT: El Paso is in the dry, sunny westernmost corner of Texas. On the border with Mexico, the city offers a unique southwest blend of cultures and traditions. Established more than 400 years ago on the shores of the Rio Grande, El Paso has grown around the base of the Franklin Mountains. Averaging 302 days of sunshine annually, El Paso has rightfully earned the nickname of "the Sun City."

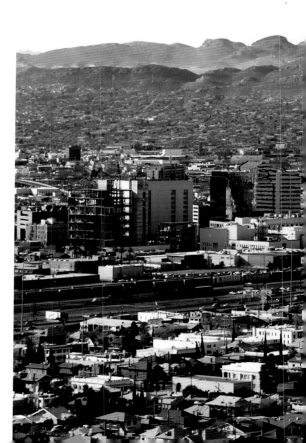

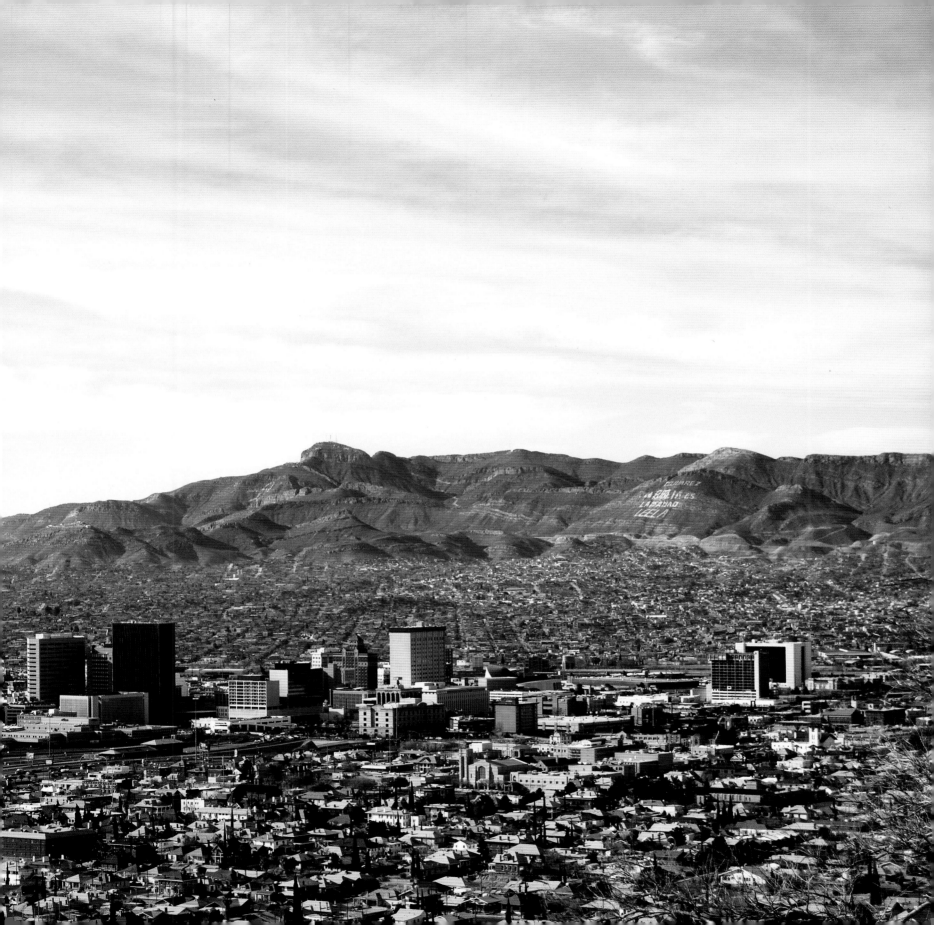

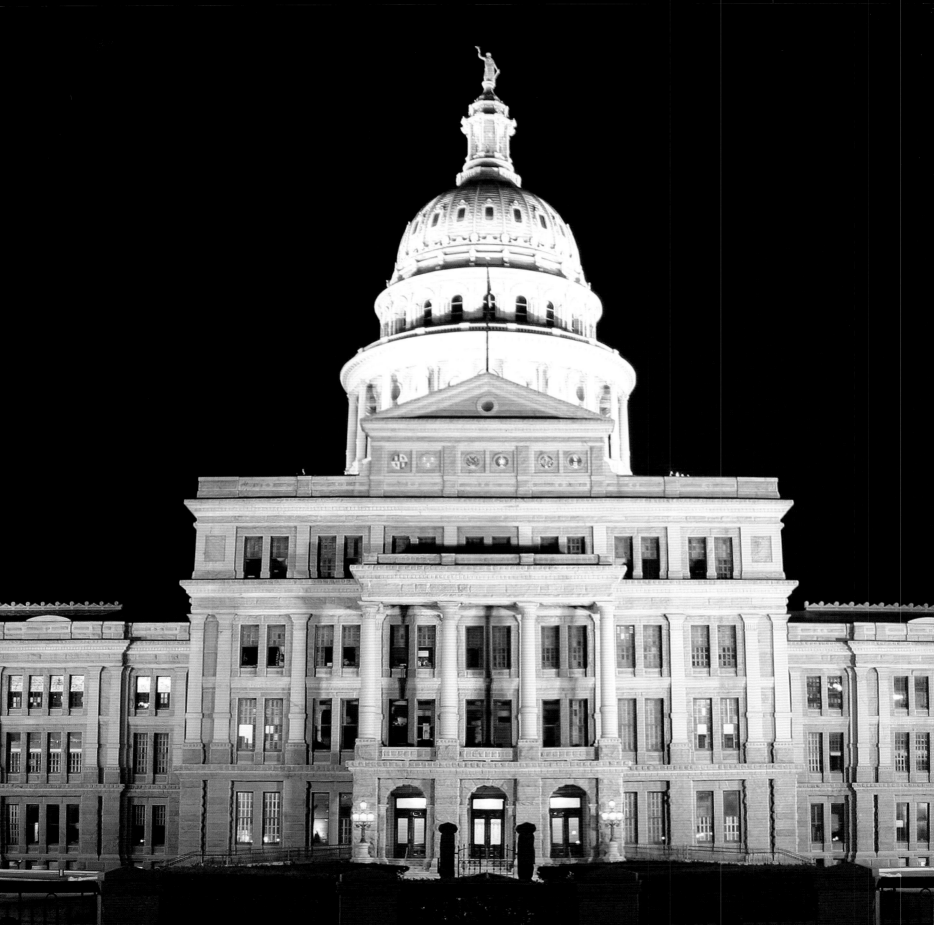

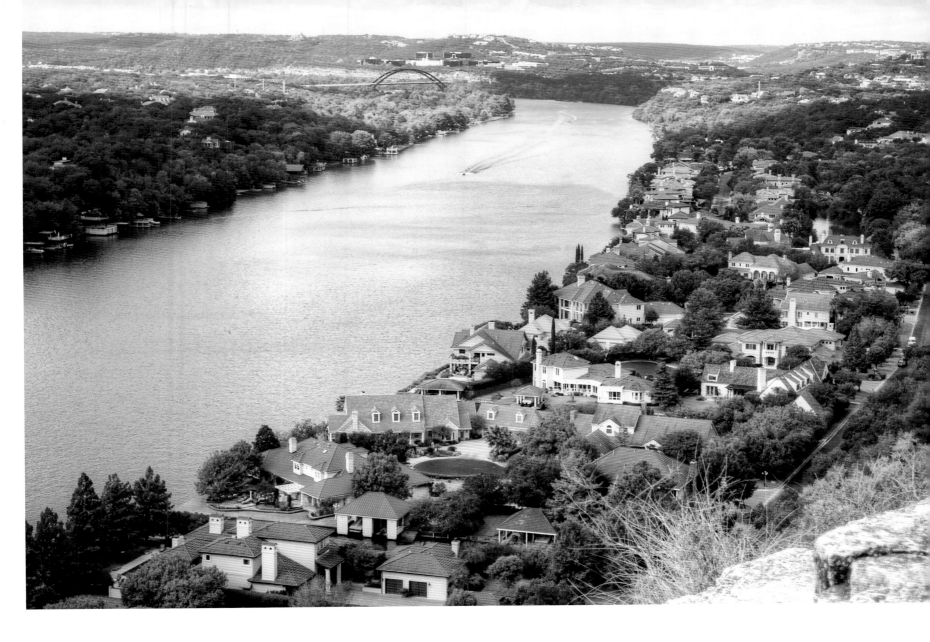

The view from the top of 775-foot Mount Bonnell rewards visitors with what some residents regard as Austin's best view. Below are the blue waters of Lake Austin.

OPPOSITE PAGE: Austin boasts the largest state capitol building in the country. Built in 1888 on three acres, this Renaissance Revival–designed building is made of Texas "sunset red" granite. Its grand dome is crowned by a 16-foot statue of the *Goddess of Liberty*.

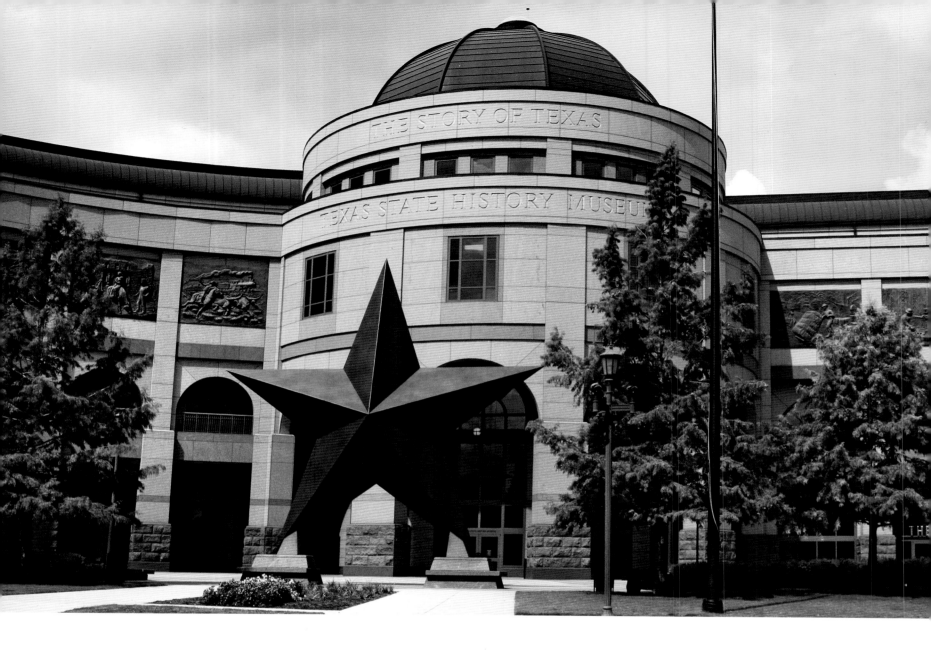

Austin's Bob Bullock Texas State History Museum is an impressive and vast complex with three floors of interactive exhibits exploring the state's history from early settlers to astronauts.

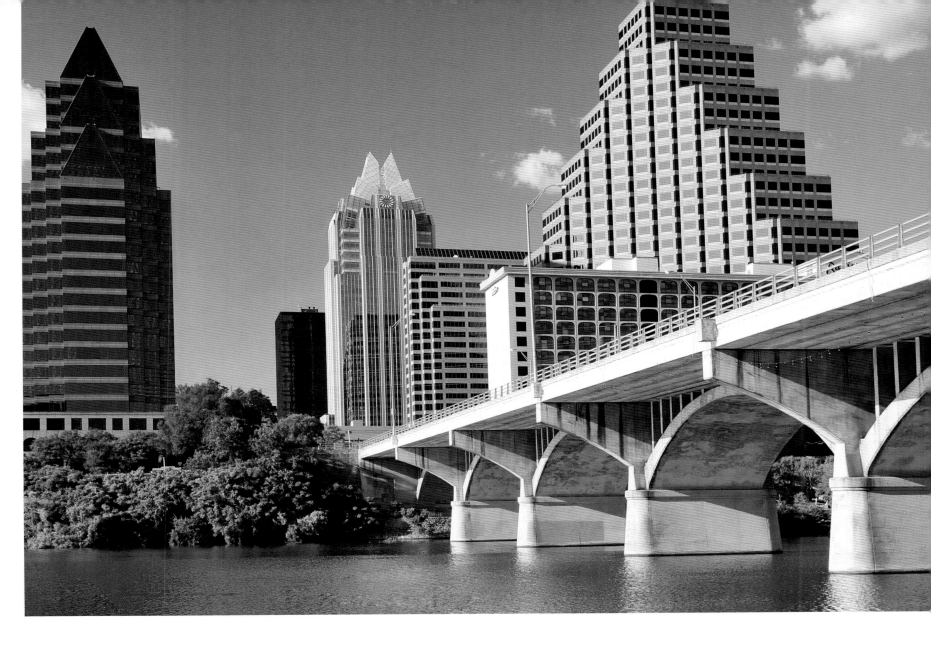

Austin, Texas's capital city, combines impressive contemporary architecture with hiking trails, historic monuments and beautiful public gardens.

The city of Austin leads the nation in the production of green energy. With its strong environmental consciousness and determination to protect its parks and gardens, this capital city continues to enhance its reputation as a progressive creative center.

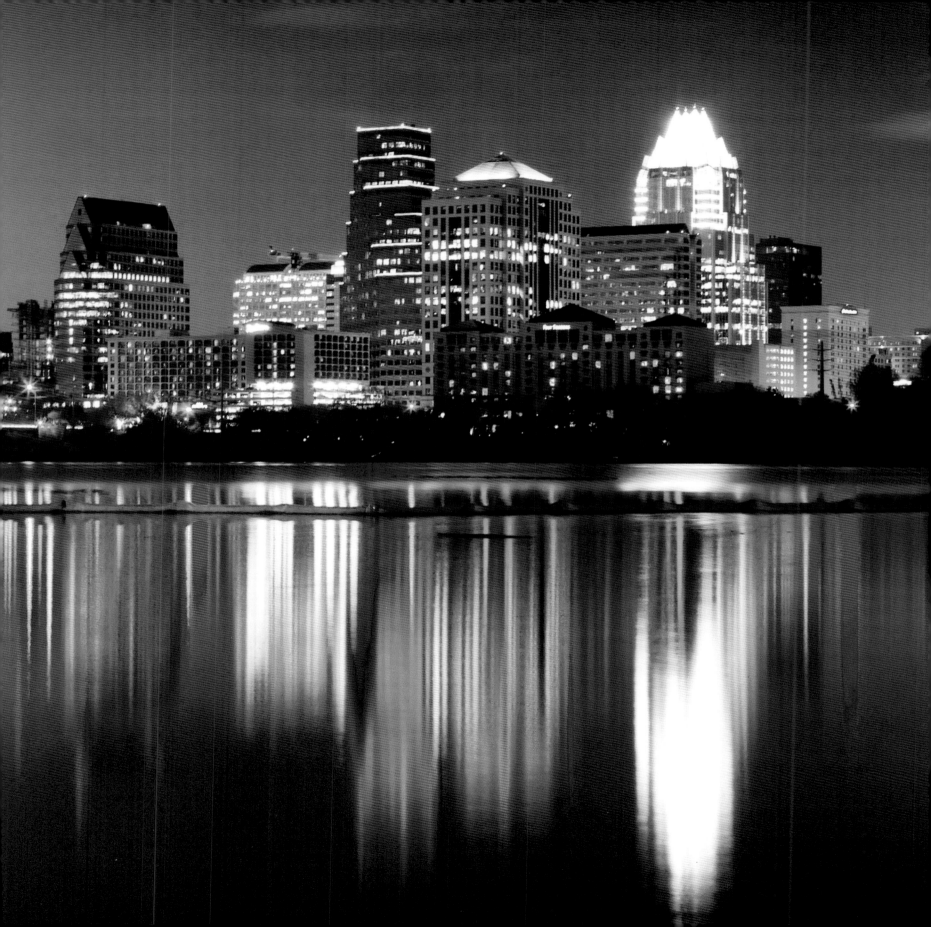

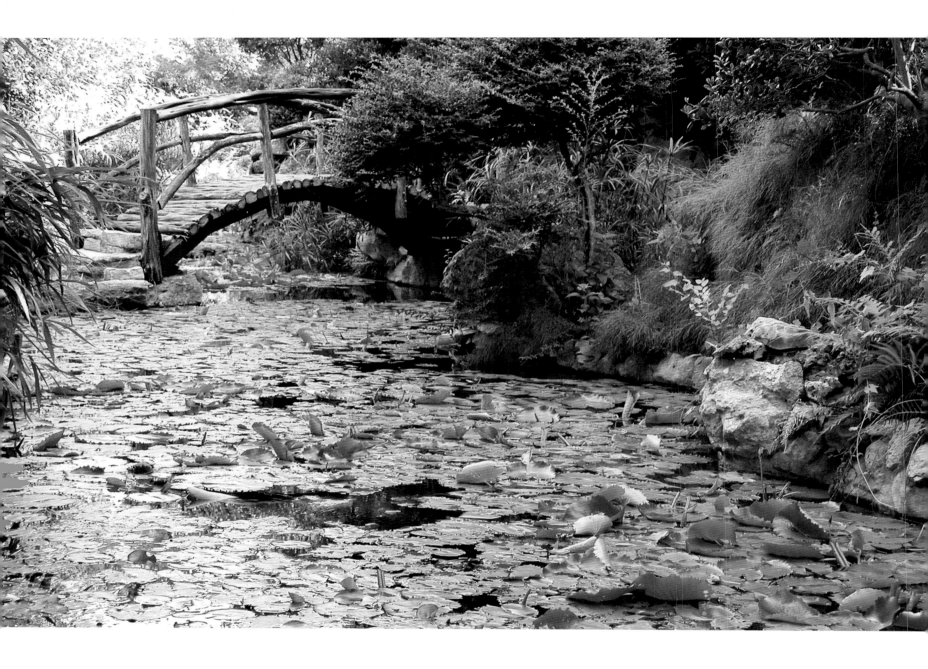

Zilker Botanical Gardens has often been called "the jewel in the heart of Austin." Rose, herb and Japanese gardens are interconnected with streams, waterfalls and Koi-filled ponds.

OPPOSITE PAGE: Central Texas is home to a robust wine industry. Its rolling hills and picturesque valleys also make it one of the most popular vacation and retirement spots in the country.

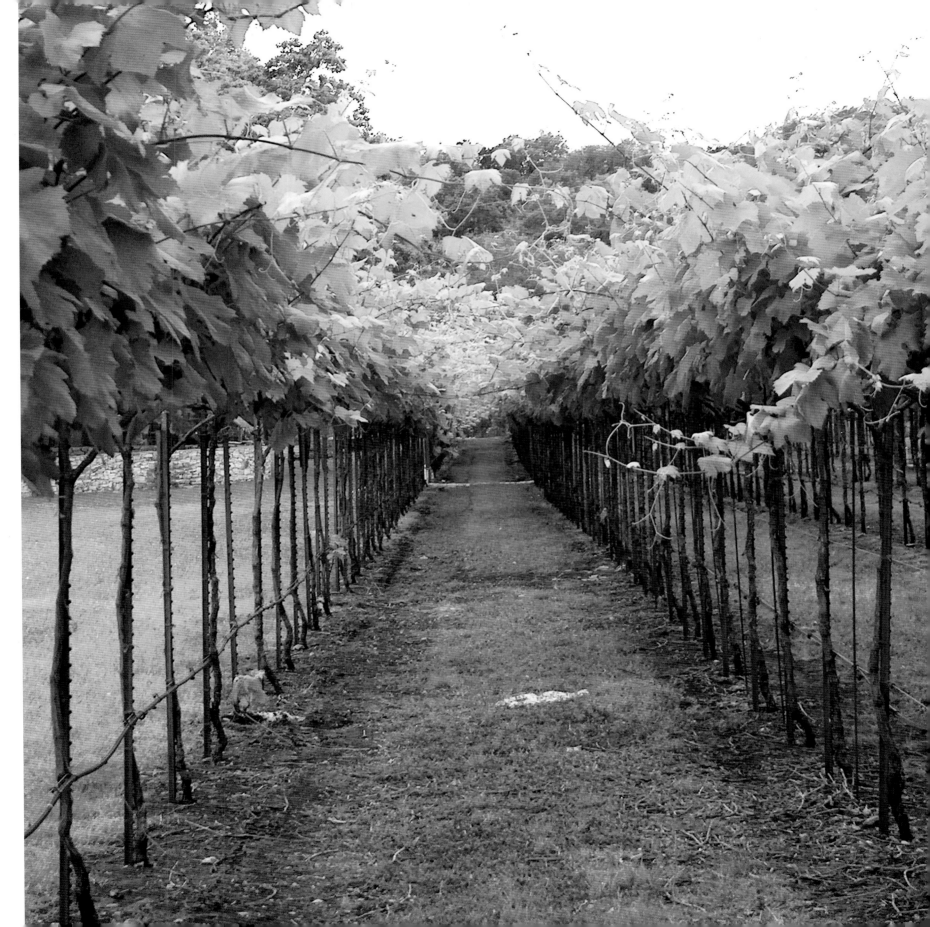

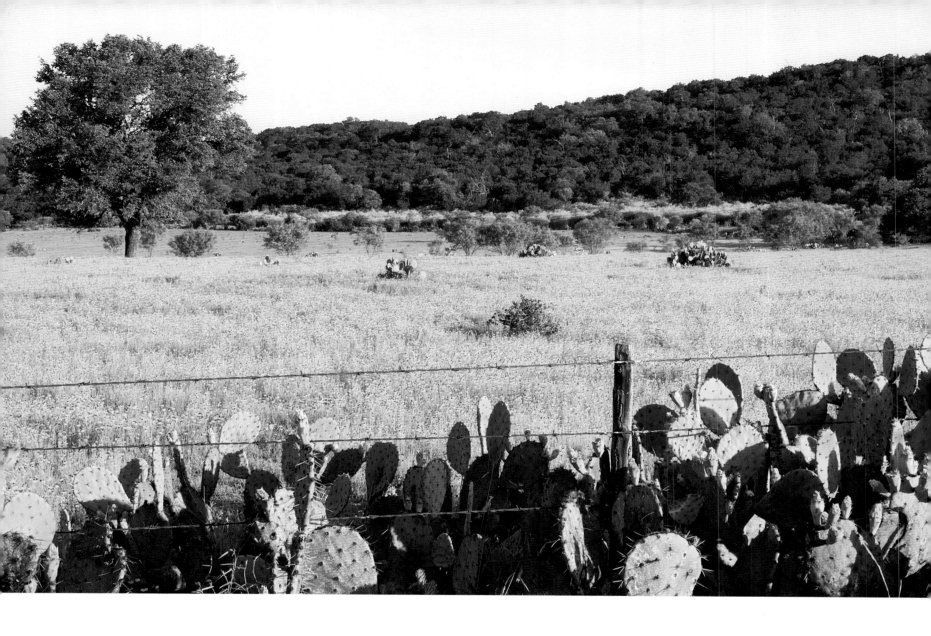

Designated the official plant symbol of Texas, the prickly pear cactus can be found throughout the American southwest. The fruits of most varieties have been a source of food for Native Americans for thousands of years.

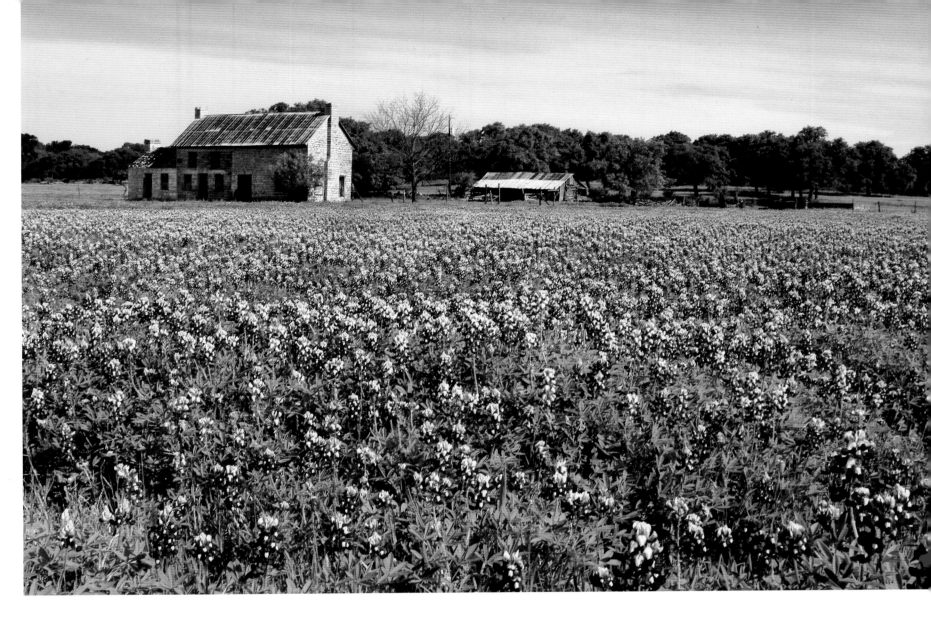

Not only the state flower, but a symbol of Texas as familiar as the Stetson or the cowboy boot, the Texas bluebonnet covers the landscape in springtime. The two predominant species of bluebonnets, or lupines, are indigenous to Texas and do not grow anywhere else in the world.

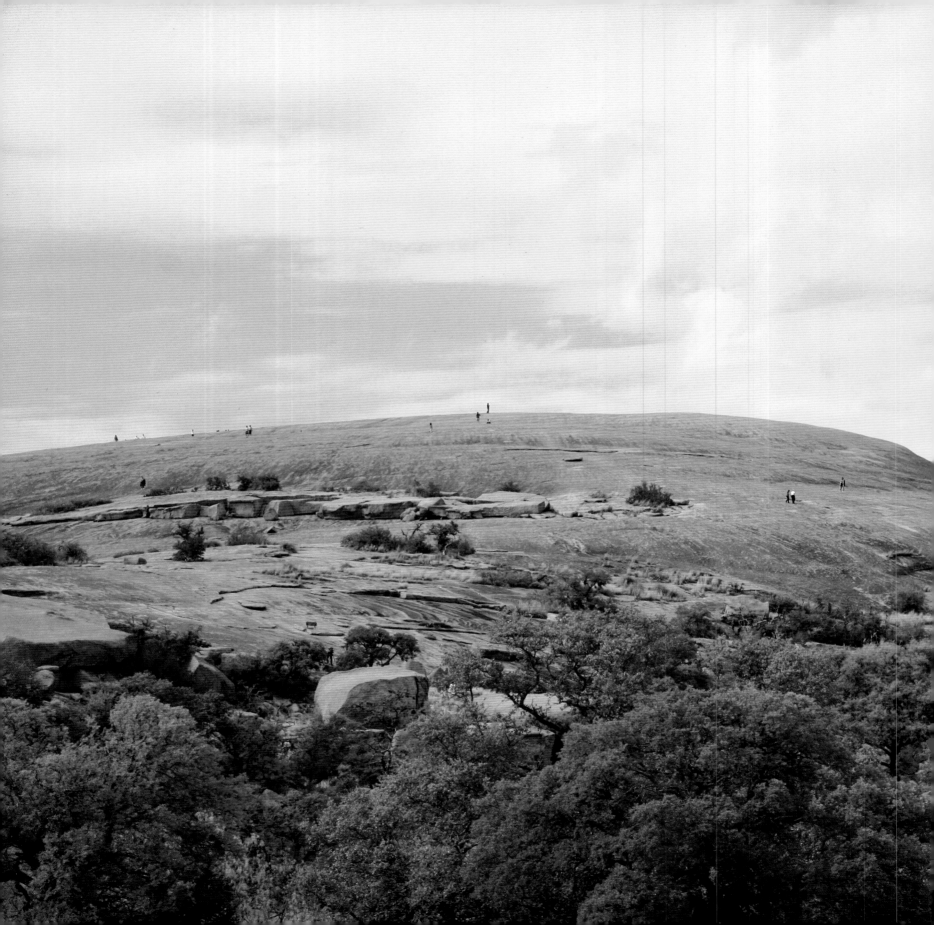

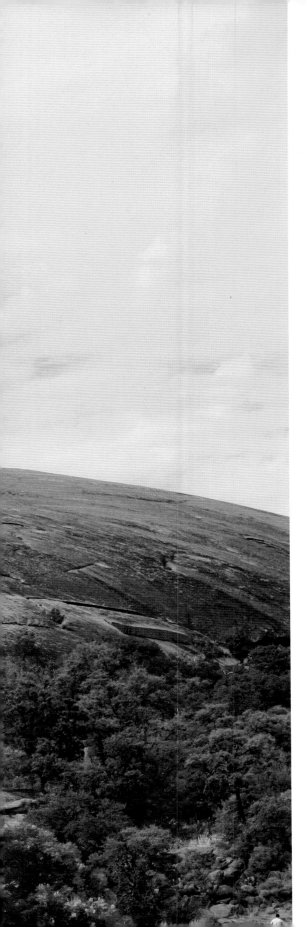

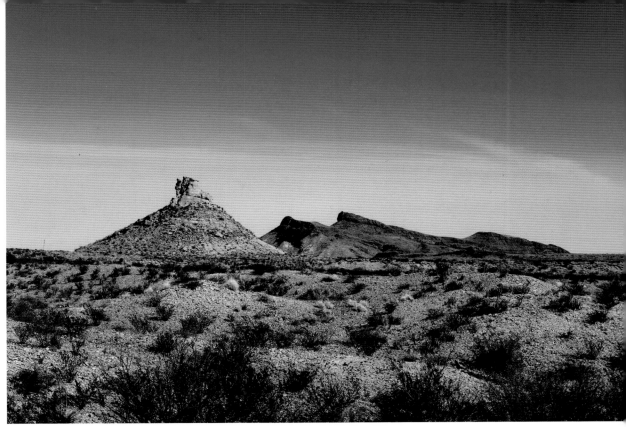

ABOVE: Hill Country is named after an early settler and surgeon, George Washington Hill, who served as secretary of war and secretary of the navy for the Republic of Texas.

LEFT: Enchanted Rock, just north of Fredericksburg, is a result of a volcanic uplifting that happened eons ago. This large stark dome of pink granite rises to almost 600 feet. An anomaly in its surroundings of rolling hills, it is in the center of the 640-acre Enchanted Rock State Natural Area.

Westcave Preserve, a natural treasure of the Texas Hill Country, possesses both extraordinary beauty and ecological diversity. The preserve's meadows are scattered with wildflowers and border a majestic limestone canyon that shelters rare plants and cypress trees. The highlight of the site is a 40-foot waterfall tumbling into an emerald pool.

OPPOSITE PAGE: For a cool retreat from the hot Texan sun, there are several spectacular caverns to visit. In these caverns there are grand natural palaces of staggering beauty.

FOLLOWING PAGE: Located on the southern tip of Texas, South Padre Island is bordered by the Gulf of Mexico and Laguna Madre Bay. Beautiful beaches, warm Gulf waters, fishing, boating and bird watching make this an ideal place to live.

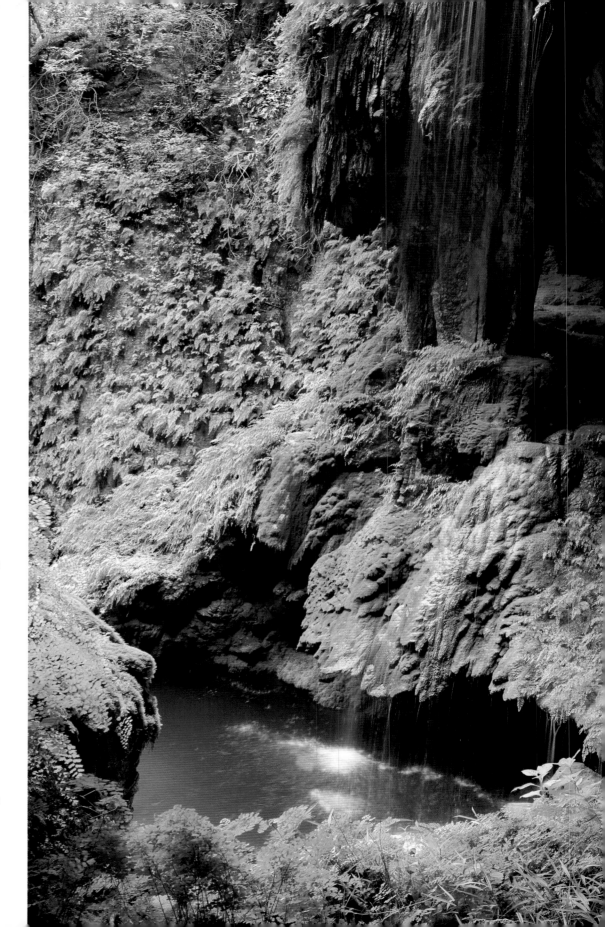

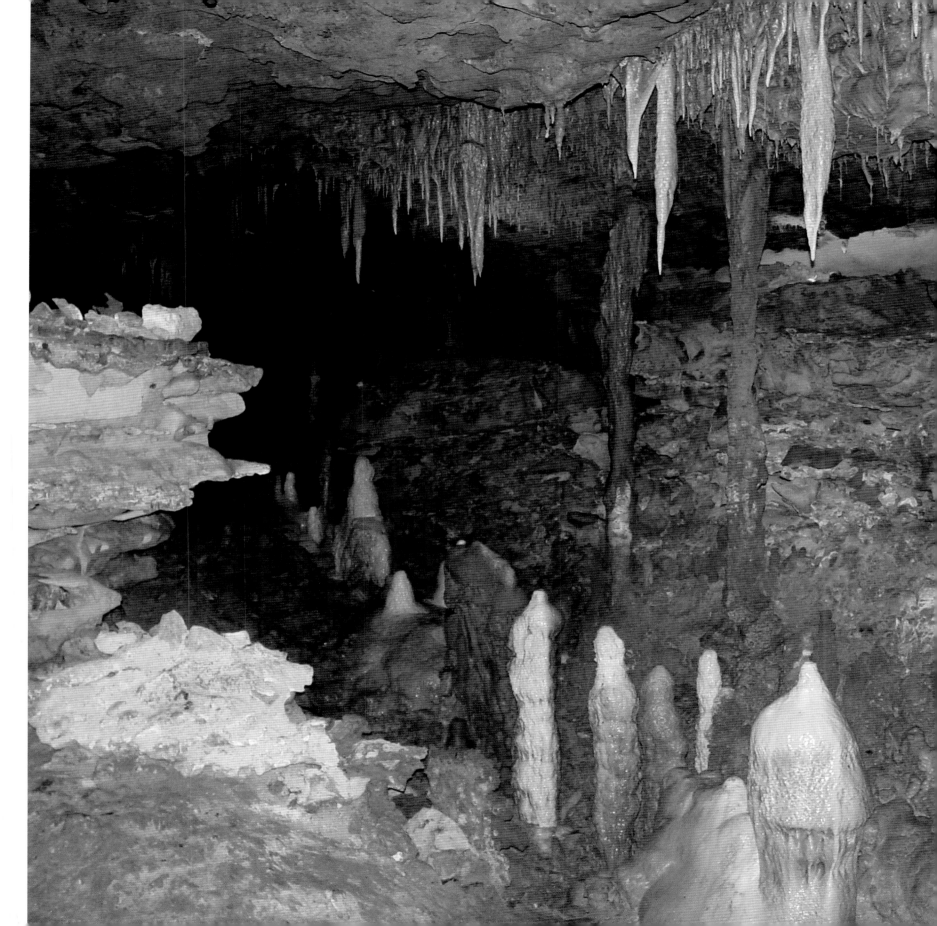

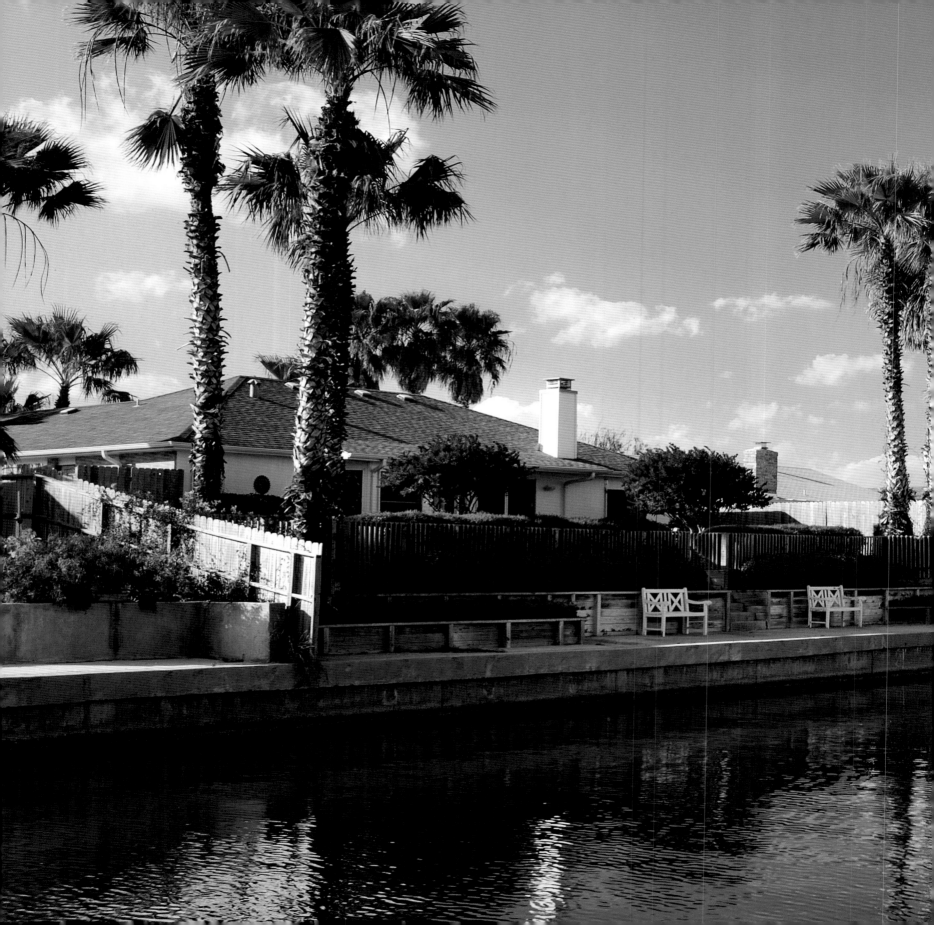

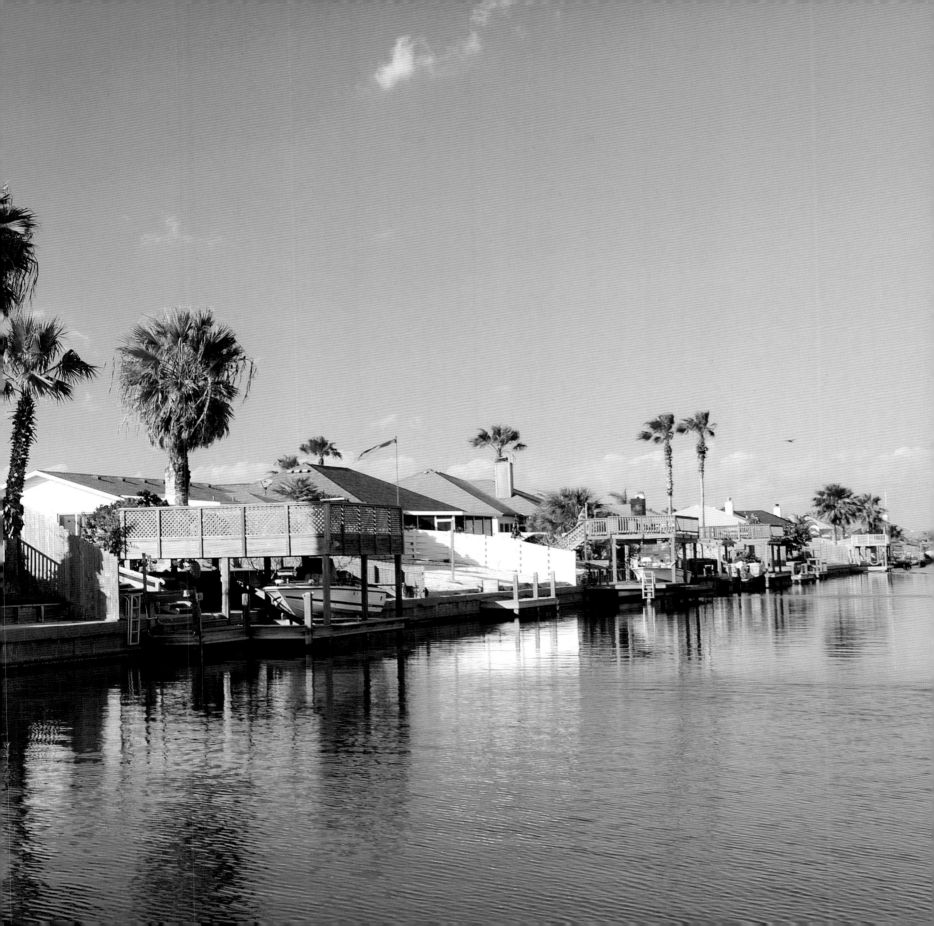

RIGHT: The beaches of South Padre Island are the number-one attraction for its many visitors. There are no privately owned beaches in Texas, so everyone is welcome to enjoy every inch of the coastline.

BELOW: Padre Island is the longest undeveloped barrier island in the world, extending 113 miles along the Texas Gulf Coast. It offers miles of white sand that shifts constantly with the wind and waves. The 130,434-acre national seashore is a protected habitat for saltwater marshes and an abundance of wildlife, particularly birds.

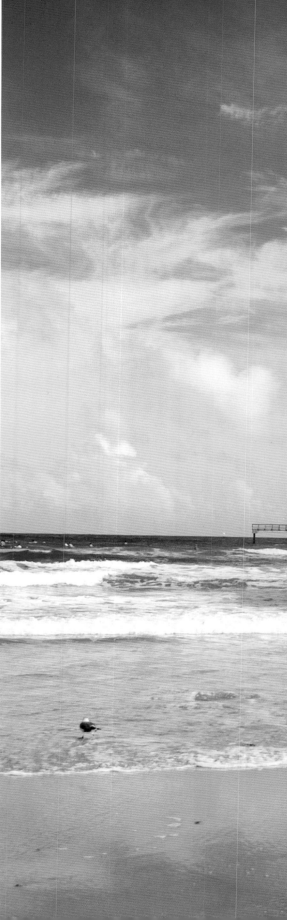

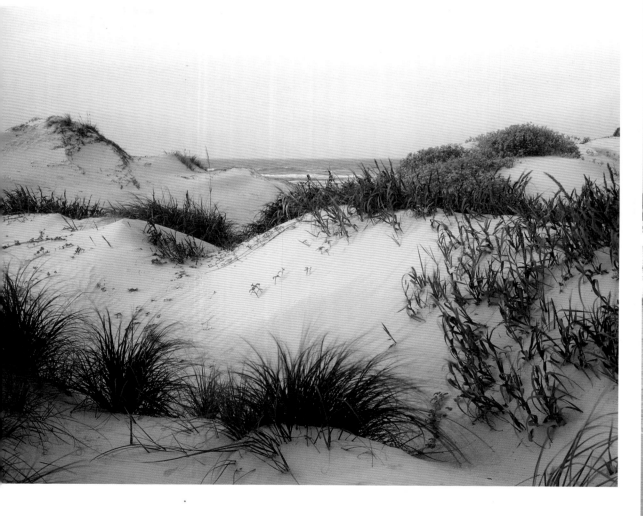

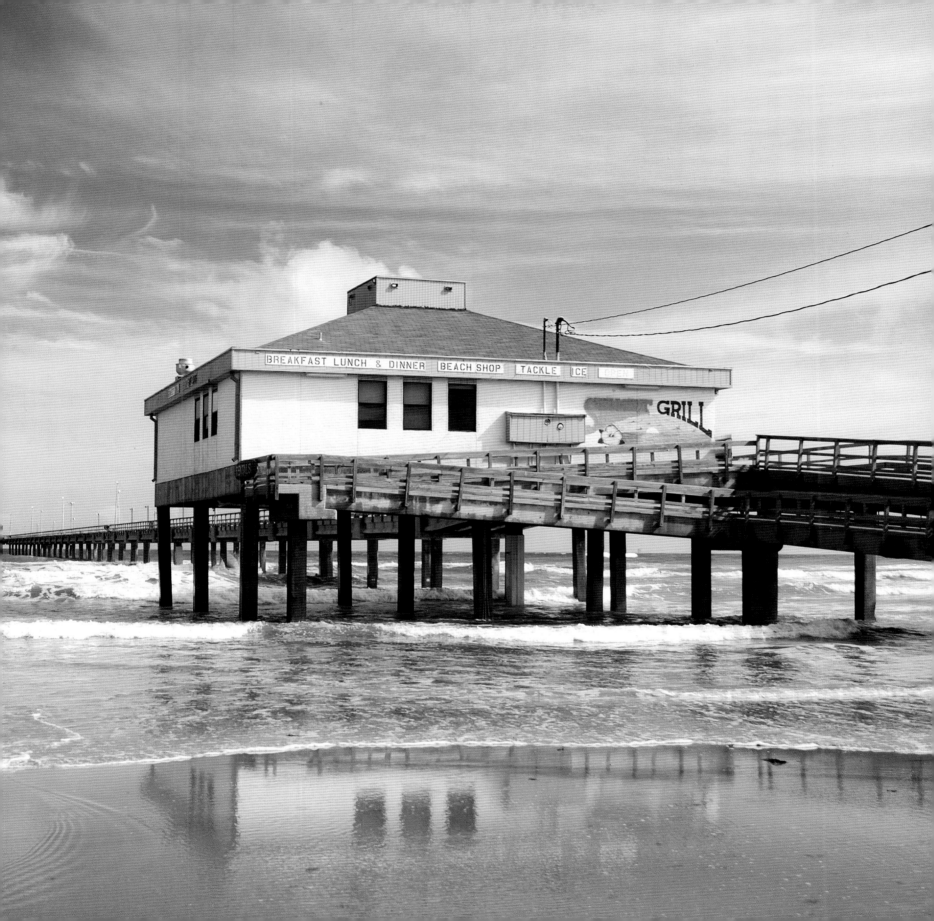

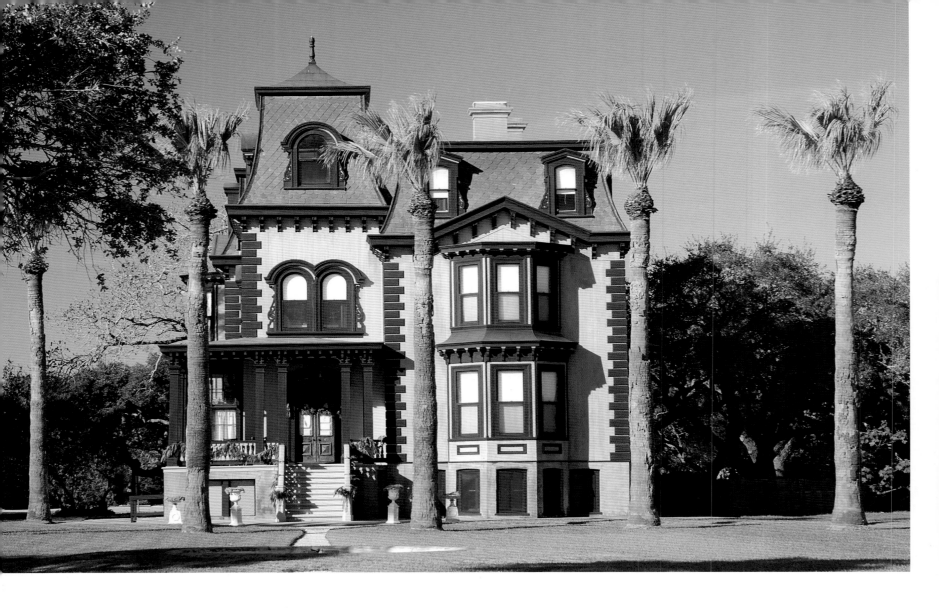

The Fulton Mansion overlooks Aransas Bay in the resort towns of Rockport-Fulton. Built between 1874 and 1877, it is one of the few surviving examples of a high-style Victorian villa in Texas. As the home of entrepreneur, engineer, inventor and rancher George Ware Fulton and his wife Harriet, it is one of the most visible reminders of the heyday of the cattle barons of South Texas.

OPPOSITE PAGE: Like many visitors, the whooping crane flies into the Rockport area of the southwest to avoid the harsh winter climate up north. The largest bird in North America, the whooping crane was almost extinct, and in 1941 only 15 birds remained. However, the ongoing efforts by conservationists have increased their population considerably. Still very rare, this adult male stands 5 feet tall with a wingspan of 8 feet.

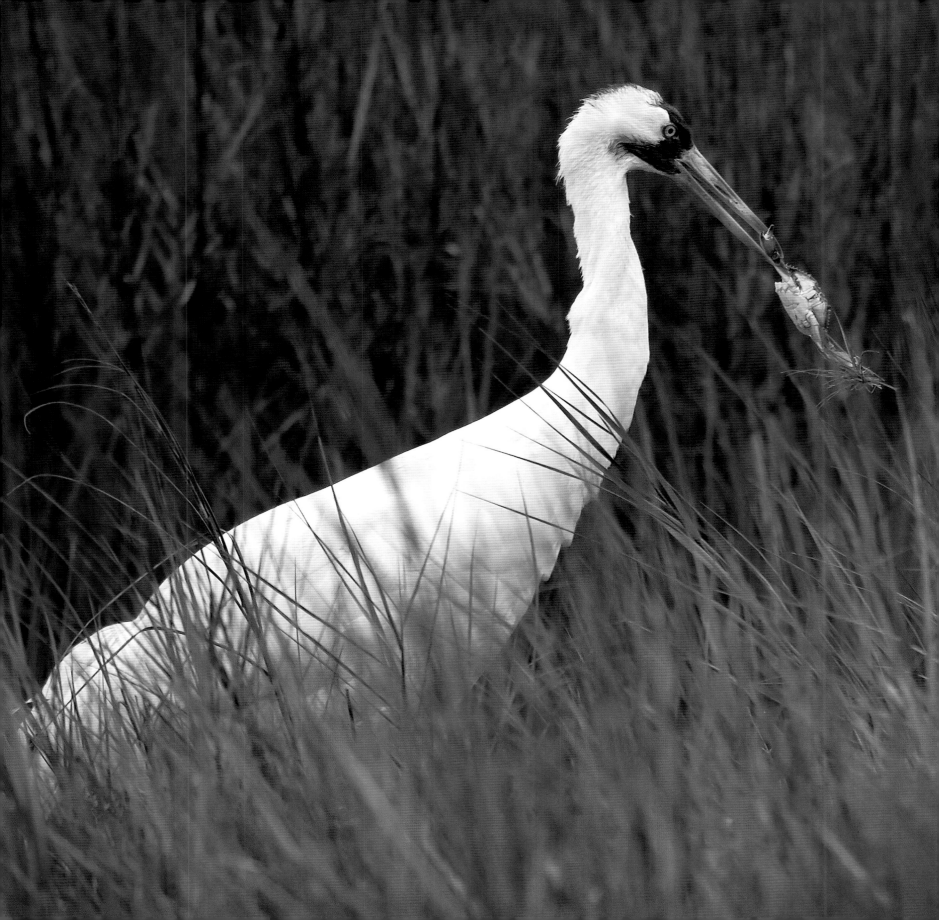

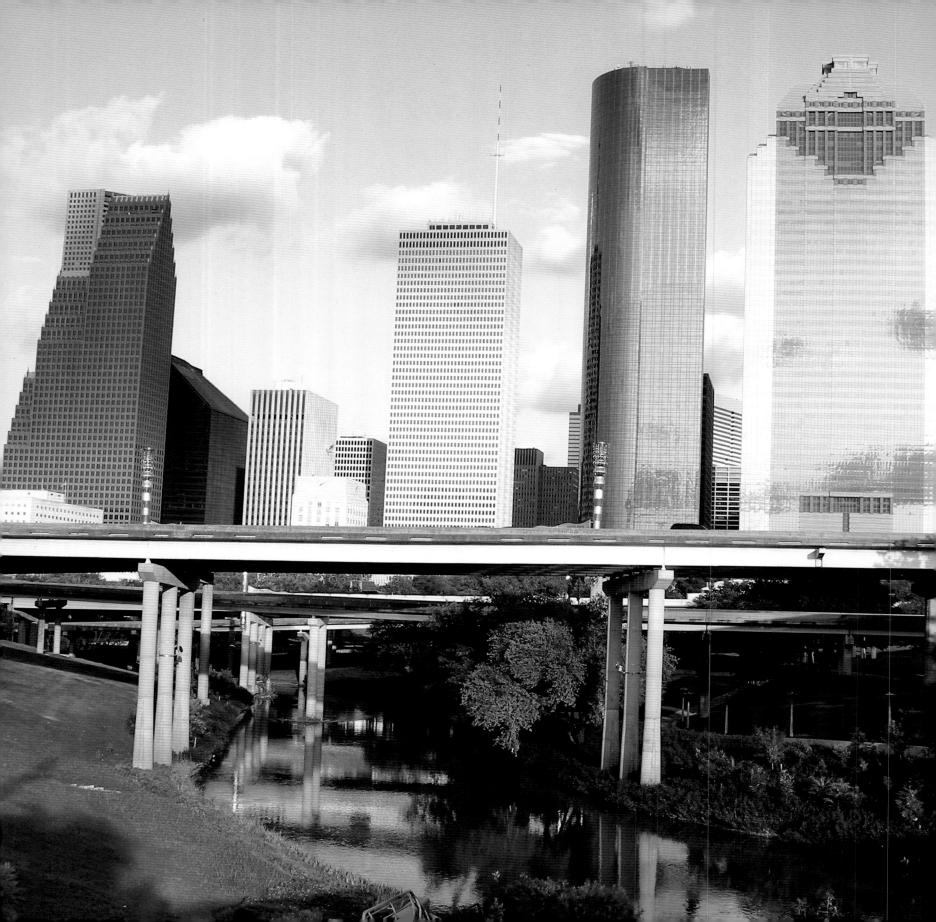

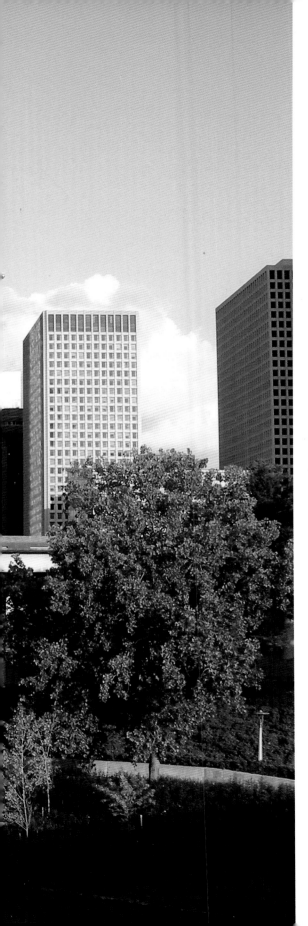

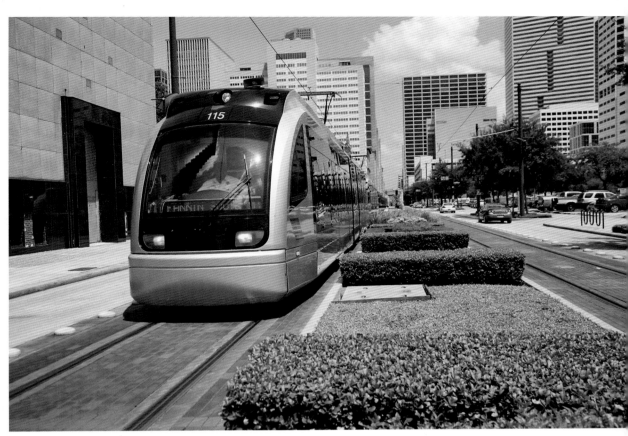

ABOVE: One of the world's energy capitals, Houston has a dynamic core of modern transportation and soaring skyscrapers. Freeways crisscross the city while the commuter trains speed along beside the landscaped median.

LEFT: The Buffalo Bayou flows through the heart of Houston providing a mirror to reflect the city's skyline.

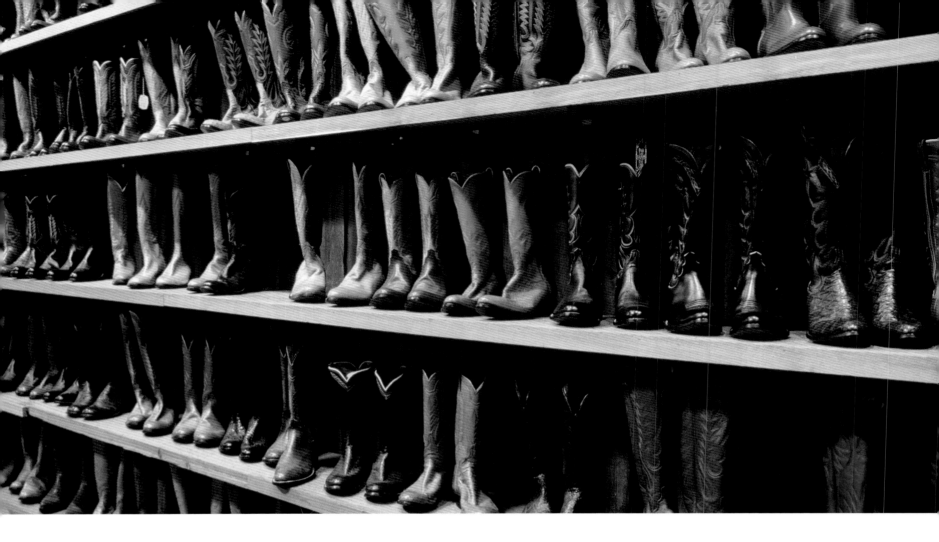

The cowboy boot is a true symbol of the Old West and Texas. Still very popular today, these boots were essential to the frontier working man. They capture the spirit of the western trail ride and life in the saddle. The term "well-heeled" comes from boots with higher heels used to control the rider's horse.

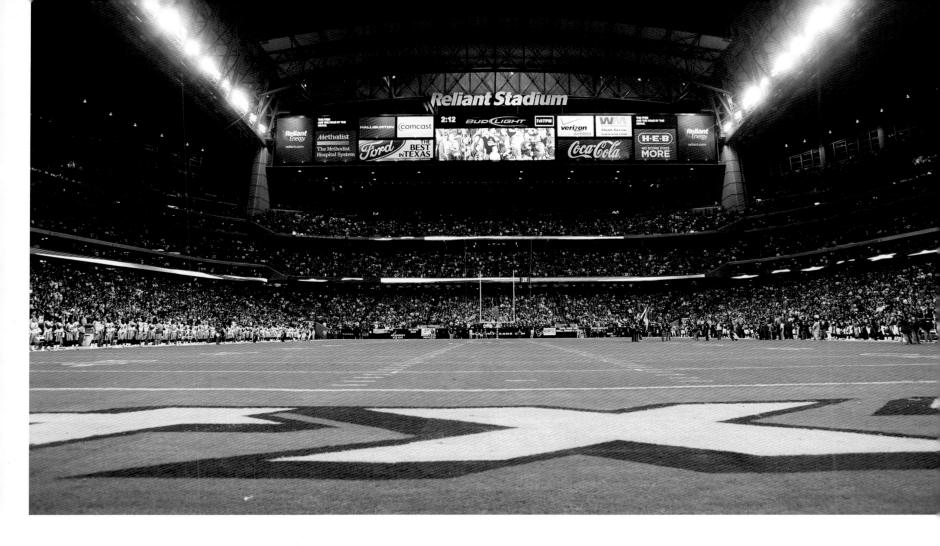

The Houston Texans get ready to face the Tennessee Titans in the magnificent Reliant Stadium. With a seating capacity of 71,500 and a retractable roof, this stadium also hosts rodeos, international soccer games and many other spectacular events.

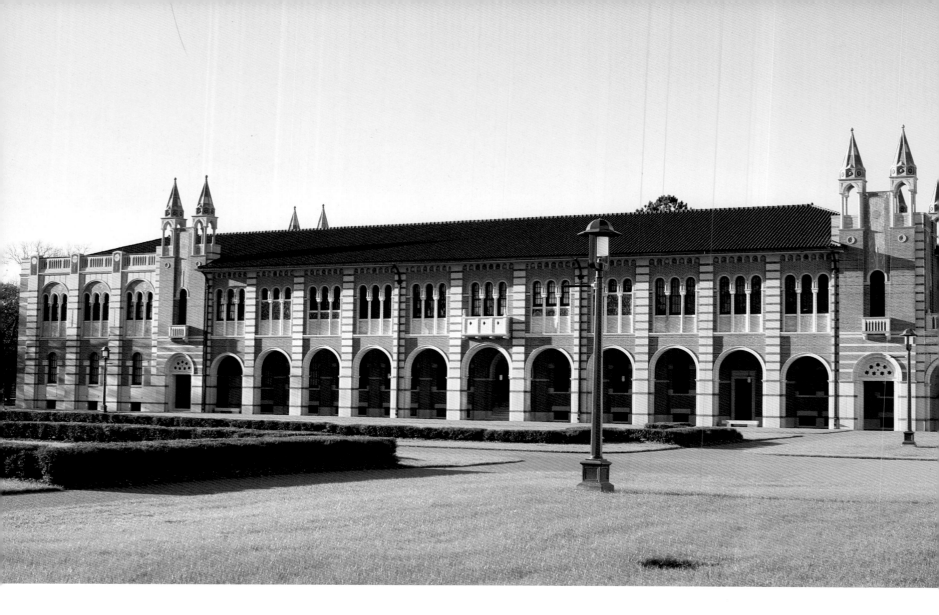

Rice University, which opened in 1912, is one of more than 25 educational institutions of higher learning in the Houston area. This small residential college boasts a spectacularly beautiful campus.

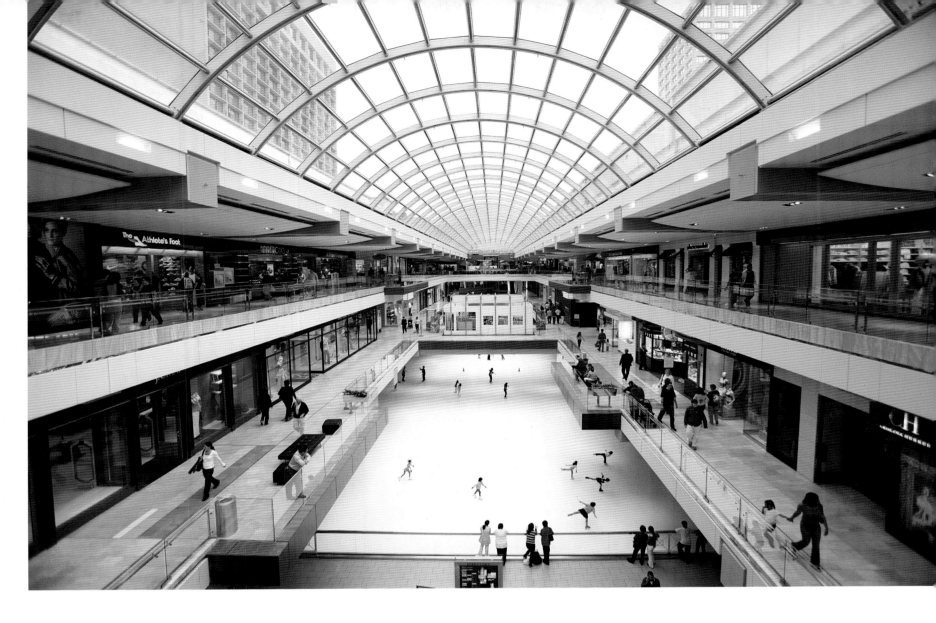

You'll find ice skating in the Houston Galleria, an upscale shopping mall and hotel complex with stunning architecture, suspended glass balconies and massive skylights. The Galleria has established itself as one of the top shopping destinations in Houston, with over 24 million visits annually.

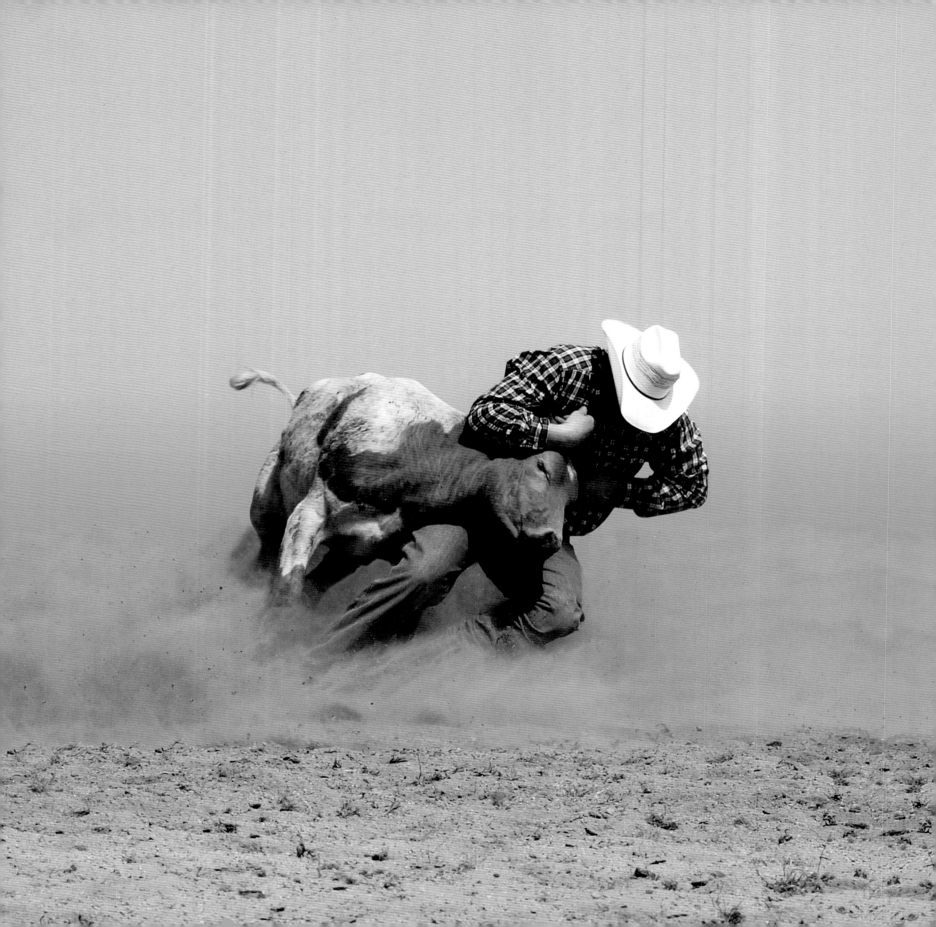

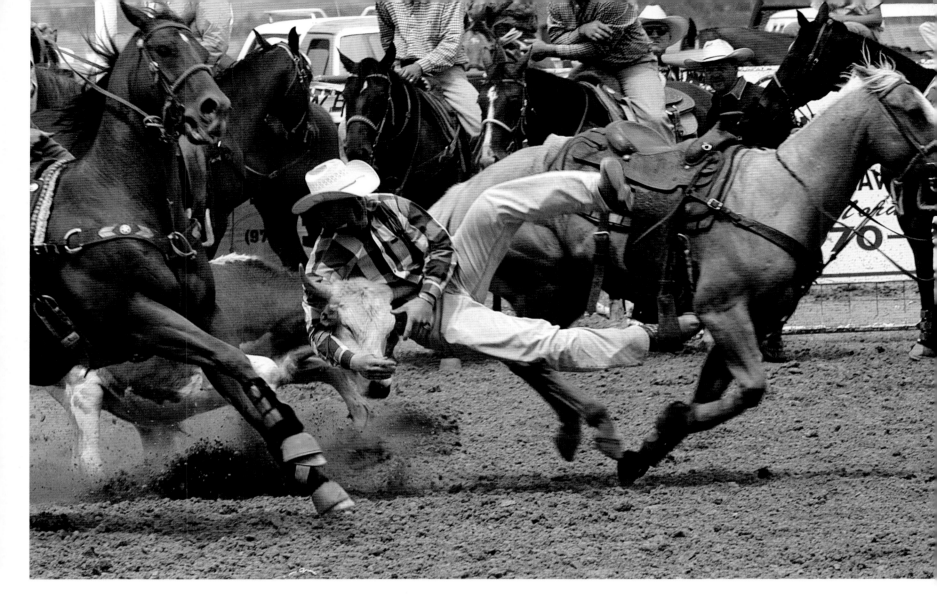

Billed as the biggest of all rodeos, the Houston Livestock Show and Rodeo takes over the city for two weeks every March. As well as all the rodeo events, there are performances by country music stars, plus carnival rides and other amusements.

OPPOSITE PAGE: Steer wrestling is one of the most popular events. The rodeo creates as much excitement now as it did back in the days of the wild west.

Houston's architecture includes a wide variety of both award-winning contemporary buildings and historic masterpieces located in various areas of the city.

OPPOSITE PAGE: Houston's magnificent City Hall was completed in 1939. The reflection pond adds elegance to the imposing architecture. In the grillwork above the main entrance are medallions of the great lawgivers from ancient times to the founding of America: Akhenaton, Julius Caesar, Moses, Charlemagne, King John and Thomas Jefferson.

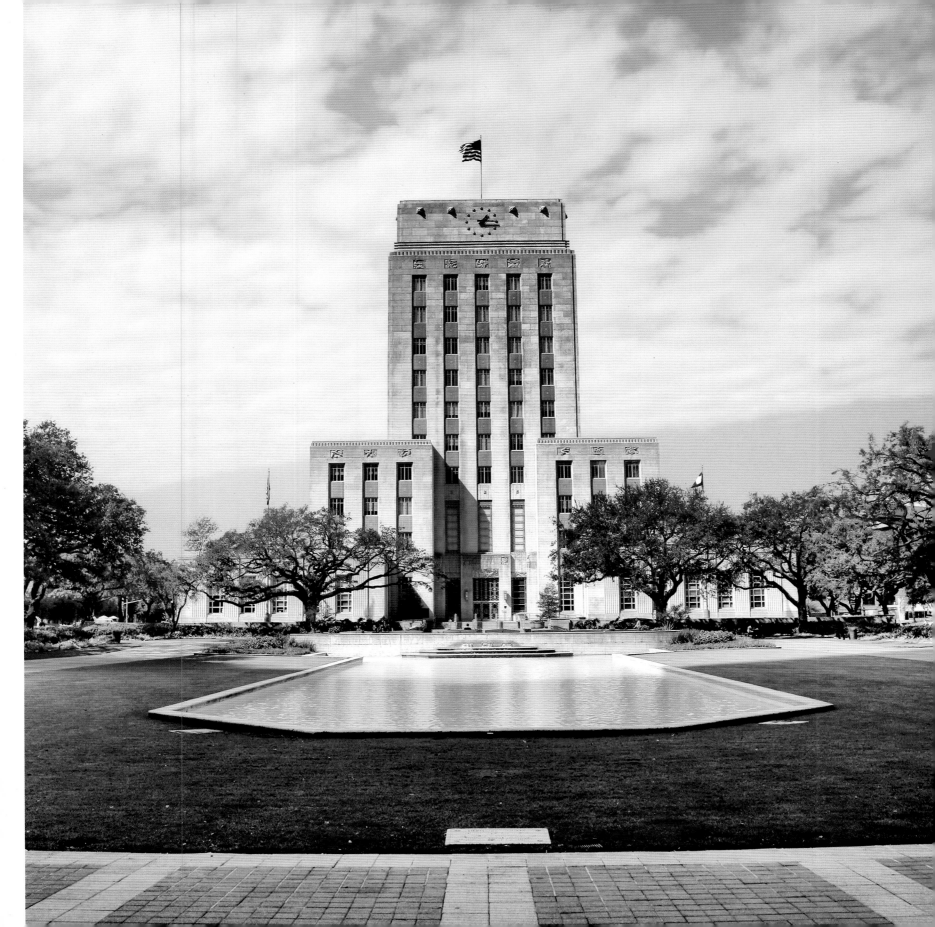

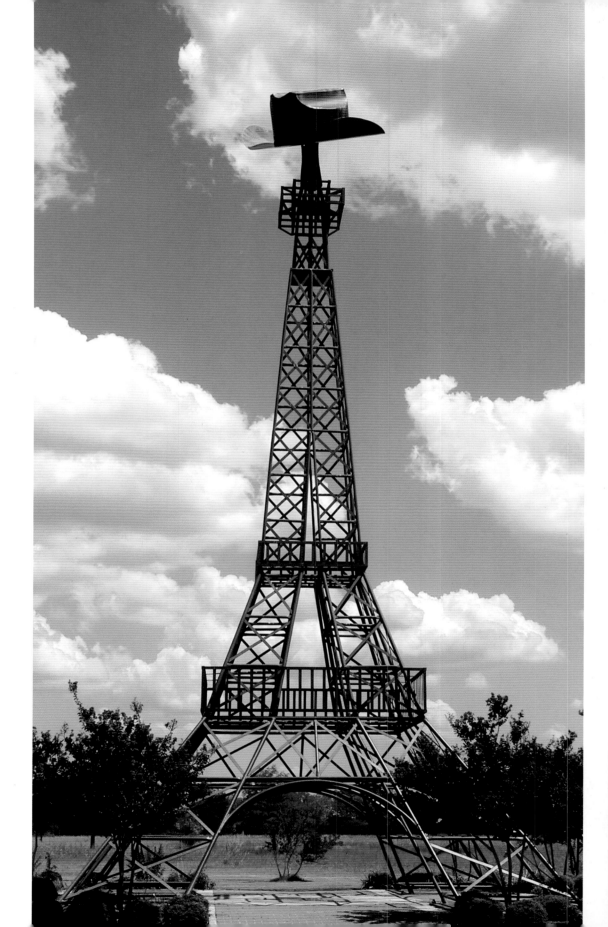

Paris is situated in northeast Texas at the western edge of the Piney Woods region. Following a tradition of U.S. cities named Paris, a 65-foot replica of the Eiffel Tower was constructed in 1993. To make this one unique, a giant red cowboy hat has been placed on top.

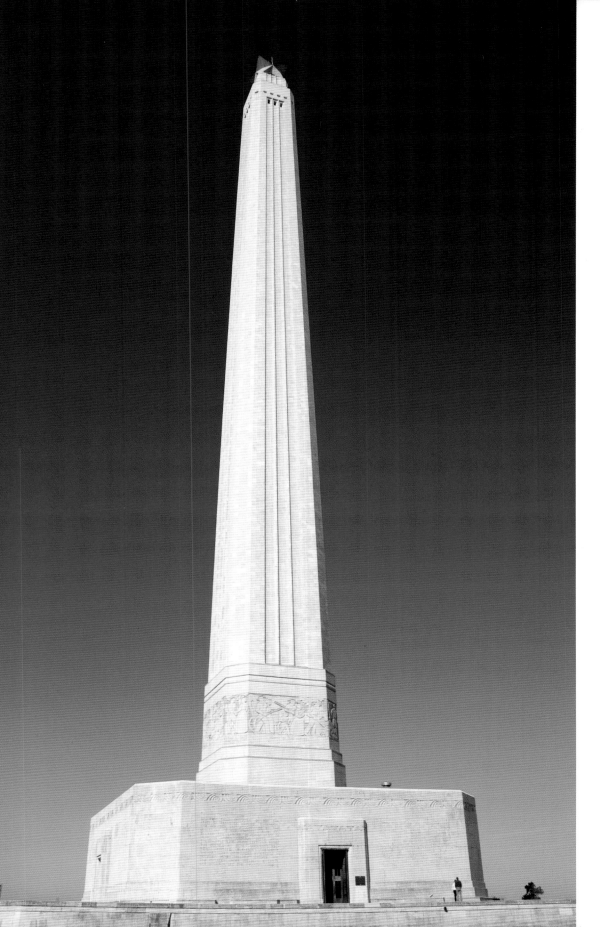

In commemoration of Texas winning its war of independence from Mexico in 1836, civic leaders erected this towering obelisk a hundred years later. It is as tall as the Washington Monument but topped with a Texas Lone Star, making it the world's tallest war memorial. The view from the observation deck, almost 489 feet above the original battlefield, is spectacular.

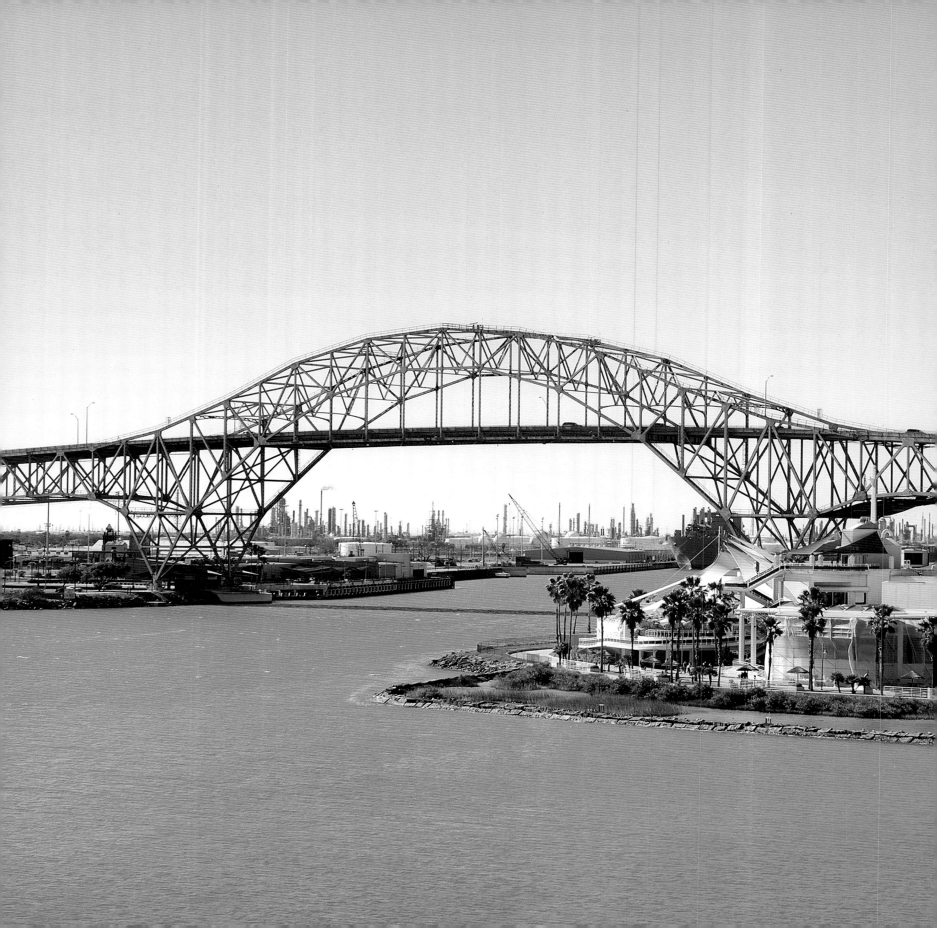

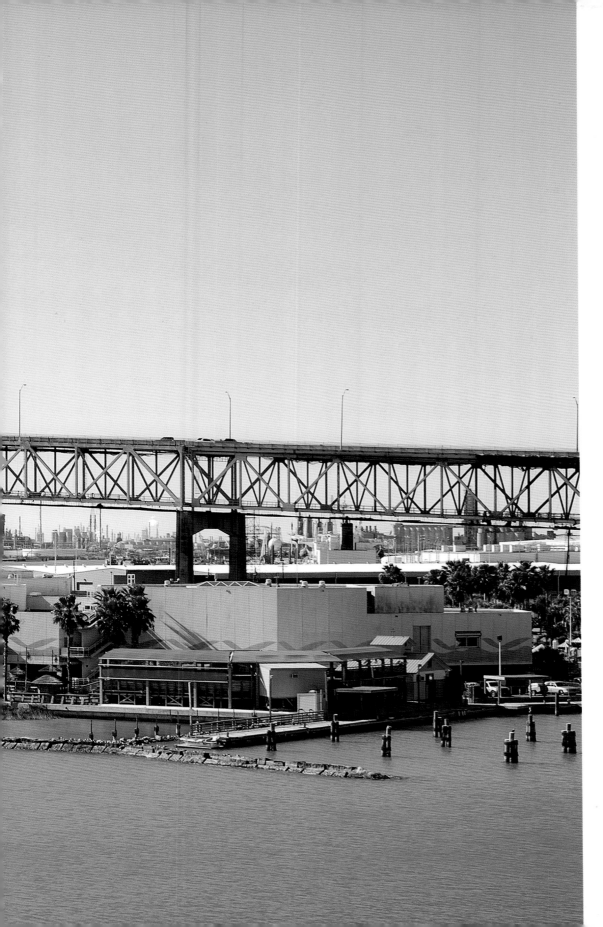

The Harbor Bridge, at 5,818 feet long, dominates the skyline of Corpus Christi. It connects two economies – tourism on the bayfront and miles of refineries along the channel. The Texas State Aquarium in the forefront is one of the state's top attractions.

FOLLOWING PAGE: Corpus Christi boasts gentle breezes and endless blue skies all year long. The tropical beaches of Corpus Christi Bay are protected from the Gulf of Mexico by barrier islands. Sailing is very popular in the bay, as are windsurfing, sea kayaking and many other watersports.

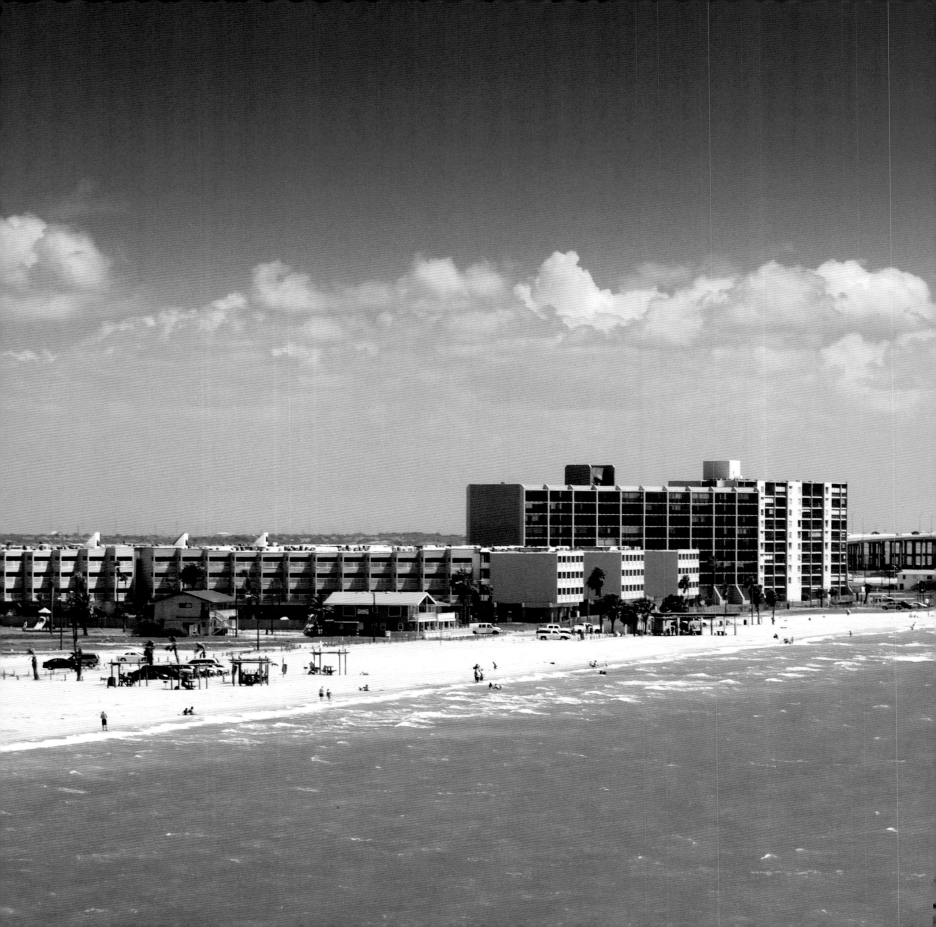

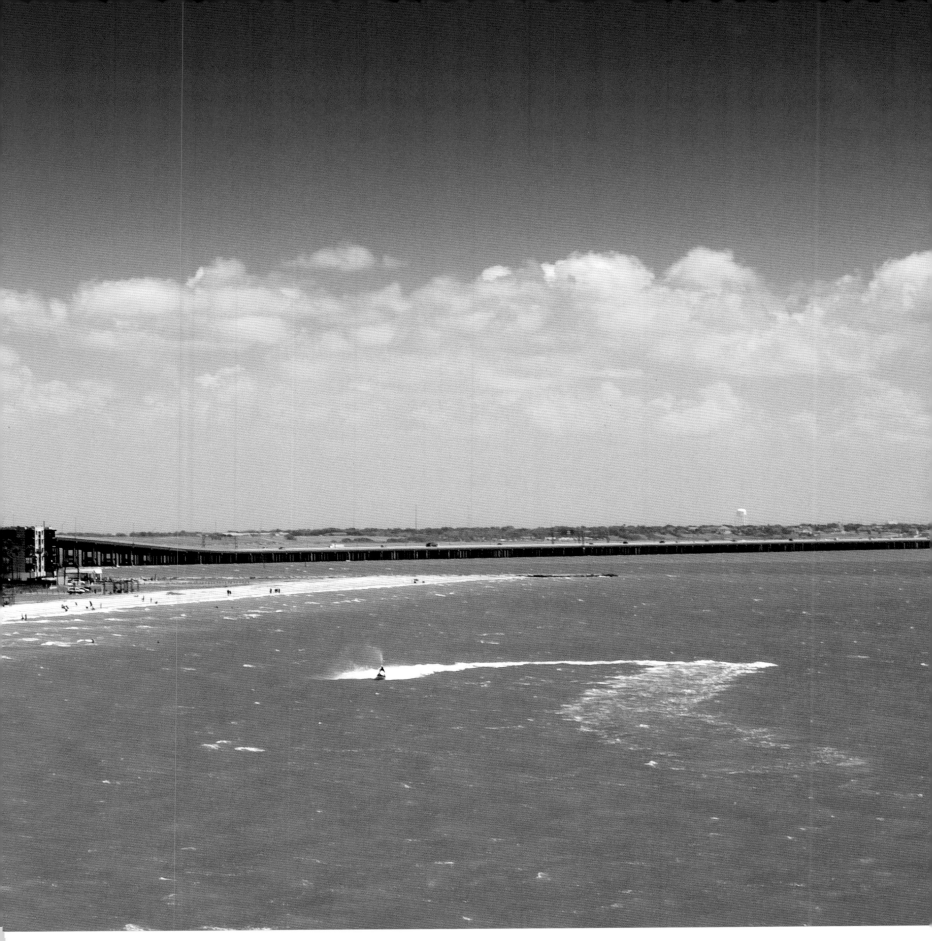

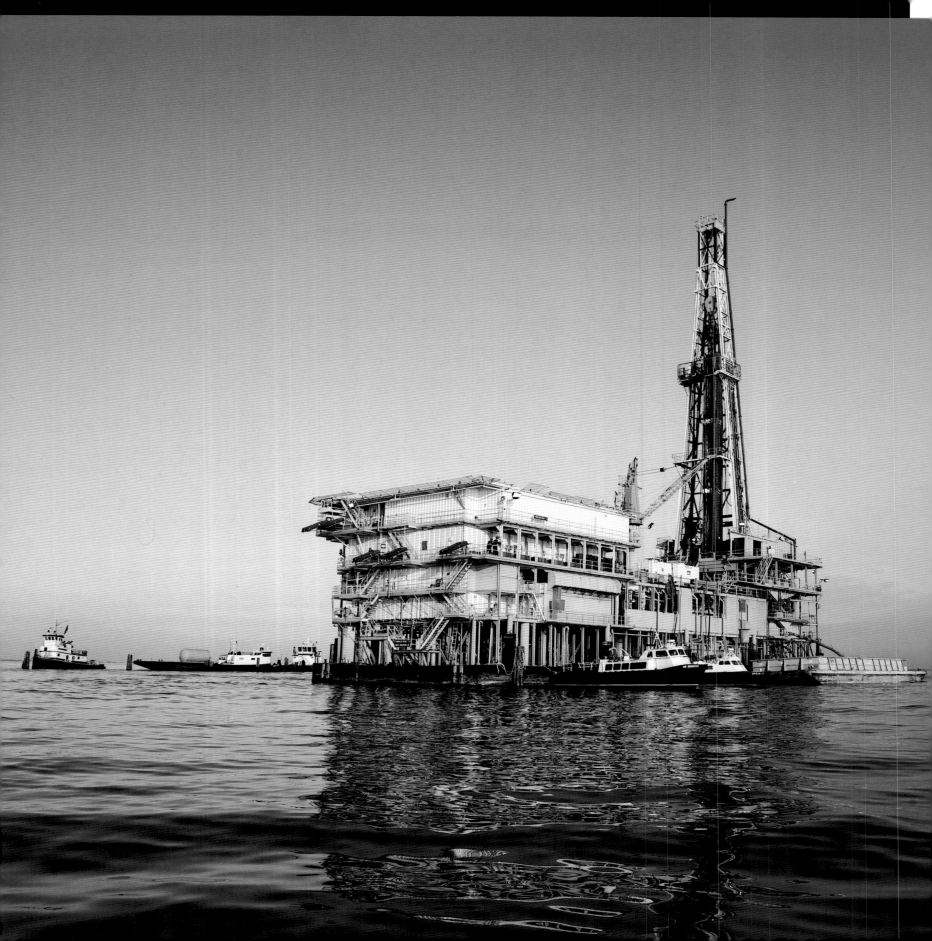

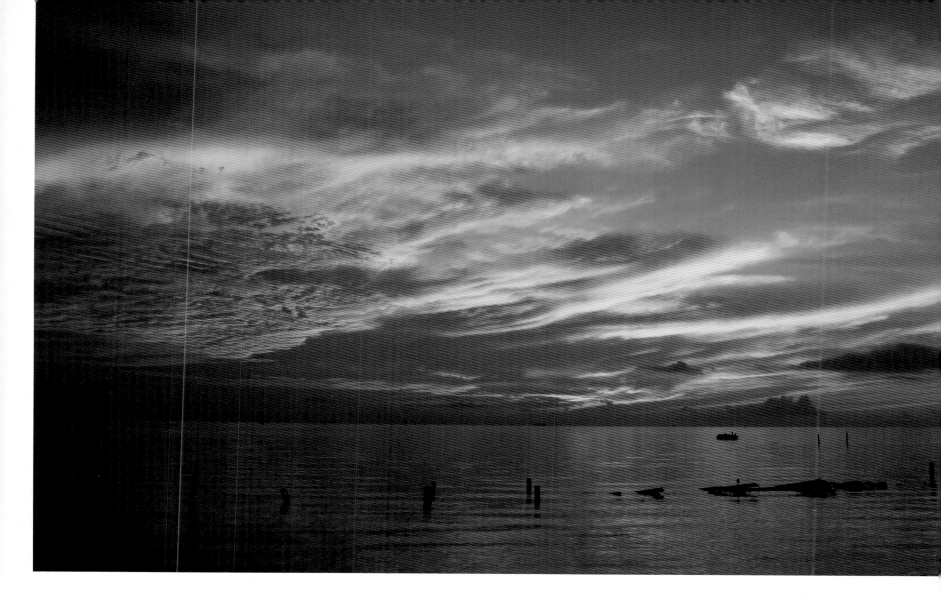

Like other coastal communities on the Gulf of Mexico, the barrier island of Galveston has withstood economic challenges as well as the fury of seasonal hurricanes. Today, Galveston is a popular tourist destination.

OPPOSITE PAGE: Oil, natural gas and fuel processing are essential to the Texan economy.

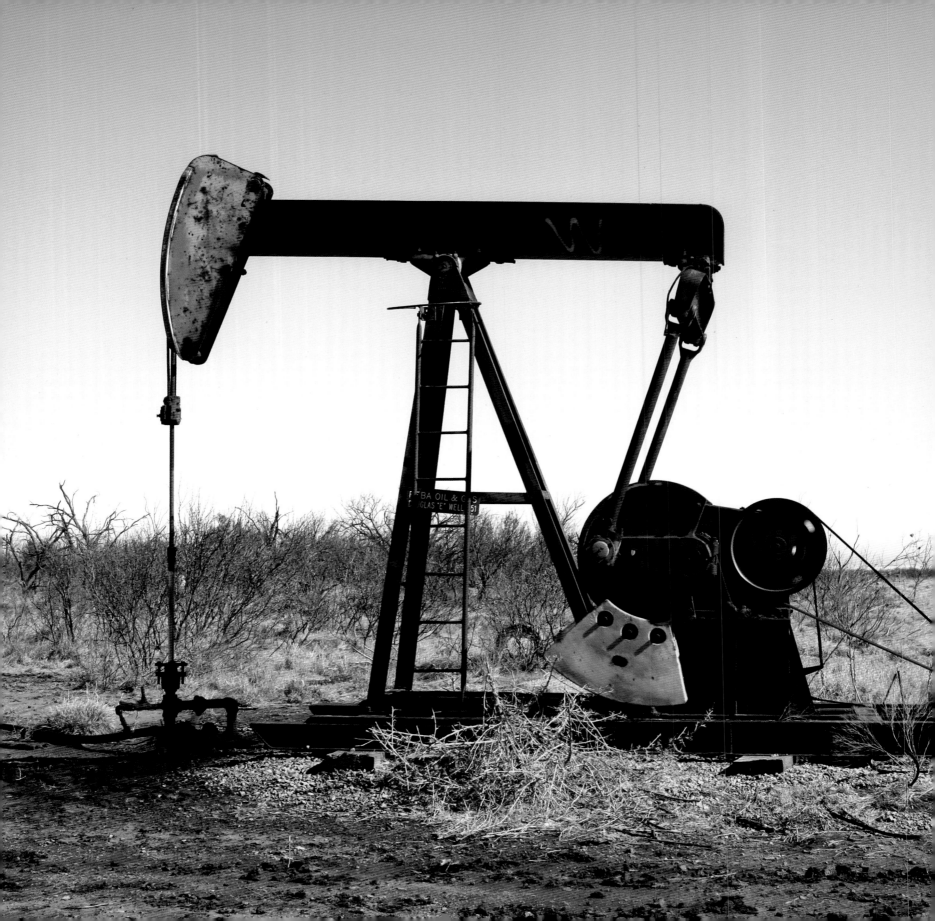

LEFT: On January 10, 1901, a spurting gusher blew mud, gas and oil more than 100 feet into the air and a new era began for Texas. From that time forward, Texas changed radically from a struggling agricultural economy to a new age of petroleum and industry. Oil has dramatically affected the way of life for thousands of Texans. The philanthropy of people who have made fortunes from the discovery, production and processing of "black gold" has benefited many cultural and educational institutions throughout the state.

BELOW: Cotton was first grown in Texas by Spanish missionaries. A report from 1745 indicates that several thousand pounds of cotton were produced annually. Texas has led the United States in cotton production since the 1880s. Today, a great deal of Texan cotton is exported, especially to Japan and South Korea.

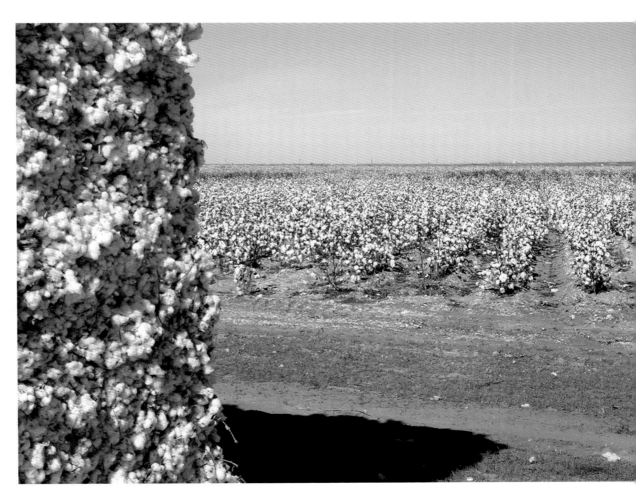

Cadillac Ranch consists of 10 vintage Cadillacs, dating from 1949 to 1964, buried nose-first in a wheat field just west of Amarillo. Stanley Marsh 3, the man behind this and several other projects in the area, was once quoted as saying, "Art is a legalized form of insanity, and I do it very well."

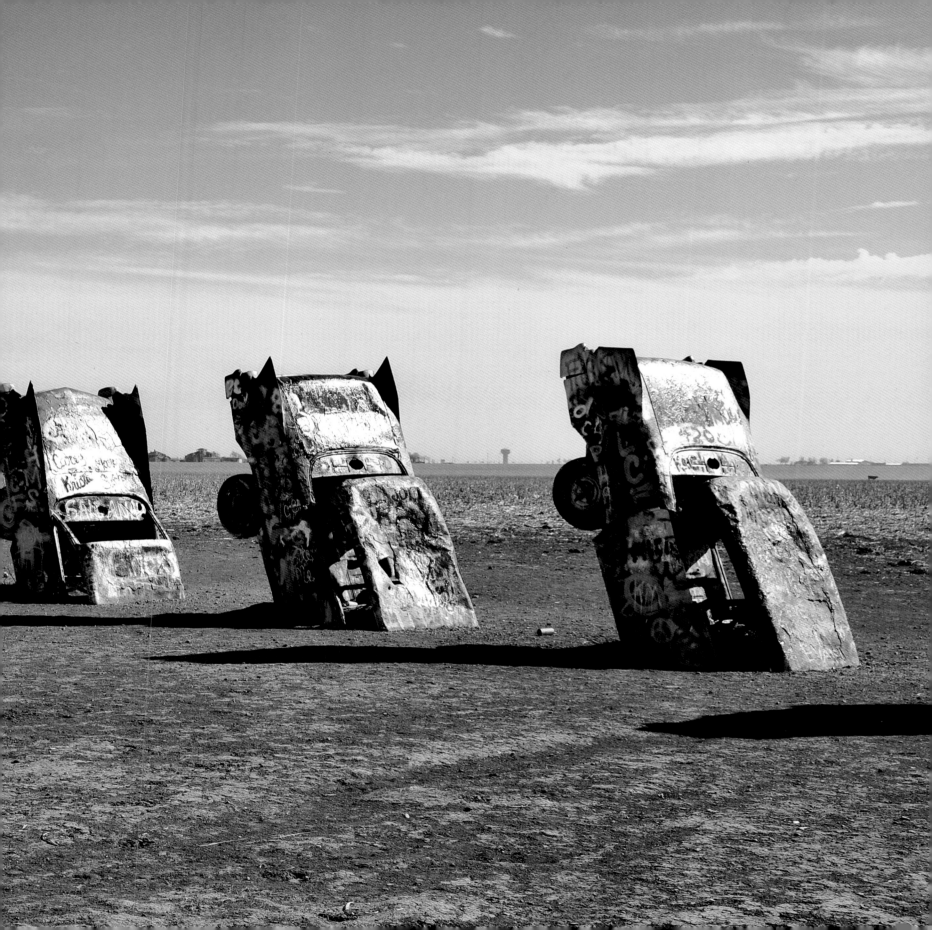

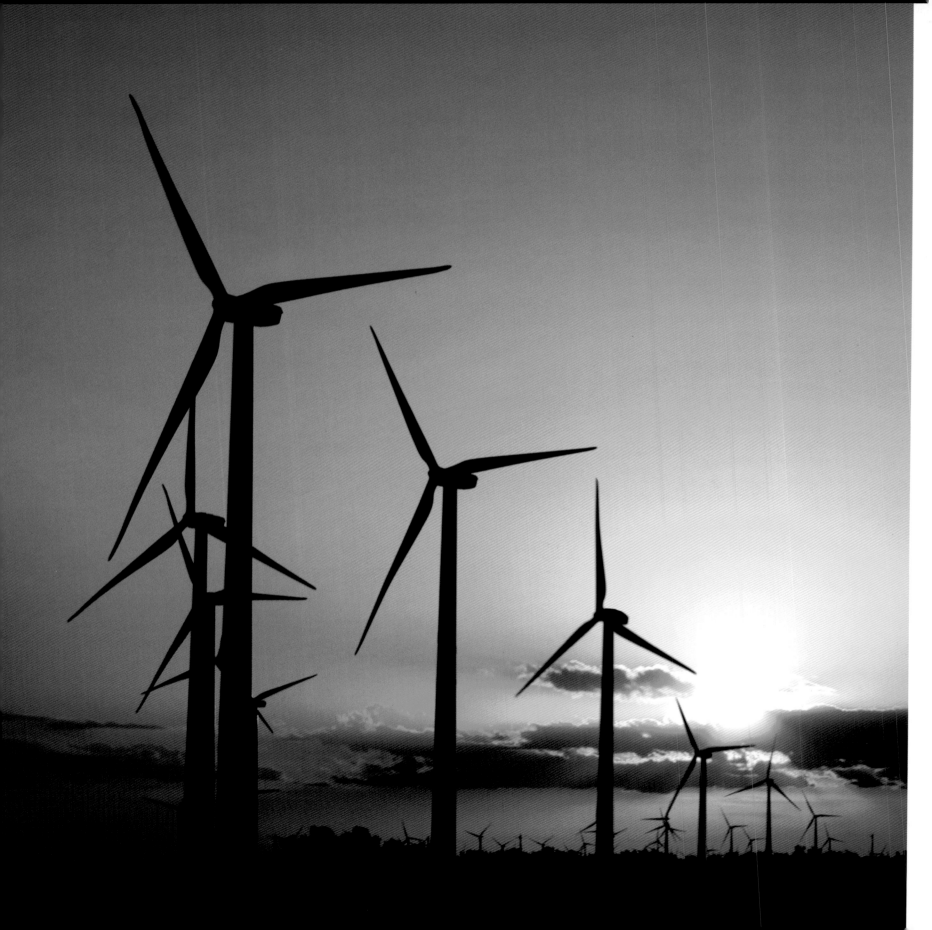

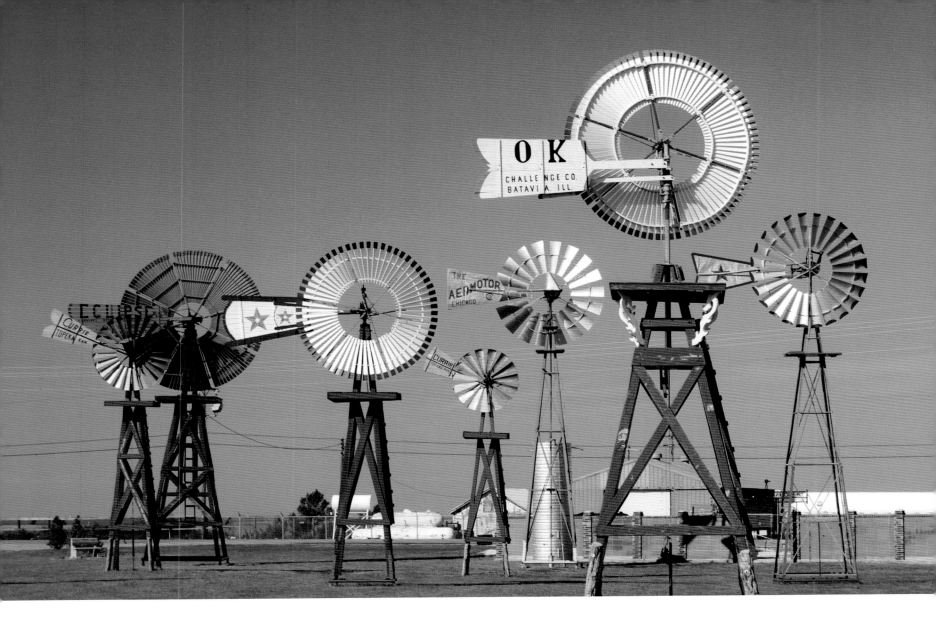

The J.B. Buchanan vintage windmill collection in Hansford County was given to the state in 1999.

OPPOSITE PAGE: Wind resource areas in the Texas Panhandle, along the Gulf Coast south of Galveston and in the mountain passes and ridge tops of the Trans-Pecos offer Texas some of the greatest wind power potential in the United States.

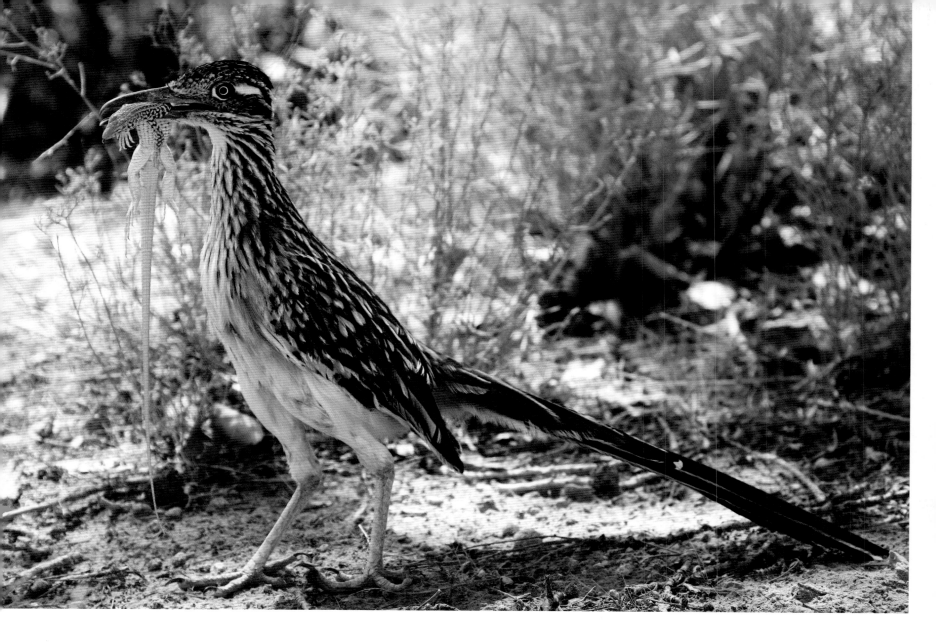

The greater roadrunner is a famous bird of the Southwest desert. This odd-looking member of the cuckoo family can reach running speeds of up to 20 miles an hour across the parched arid landscape.

OPPOSITE PAGE: Called the Lighthouse, this unusual rock formation rising 3,500 feet above sea level overlooks the massive Palo Duro Canyon, the second largest (after the Grand Canyon) in the country. Groves of juniper and cottonwood trees are scattered throughout the area, creating a natural habitat for many forms of wildlife.

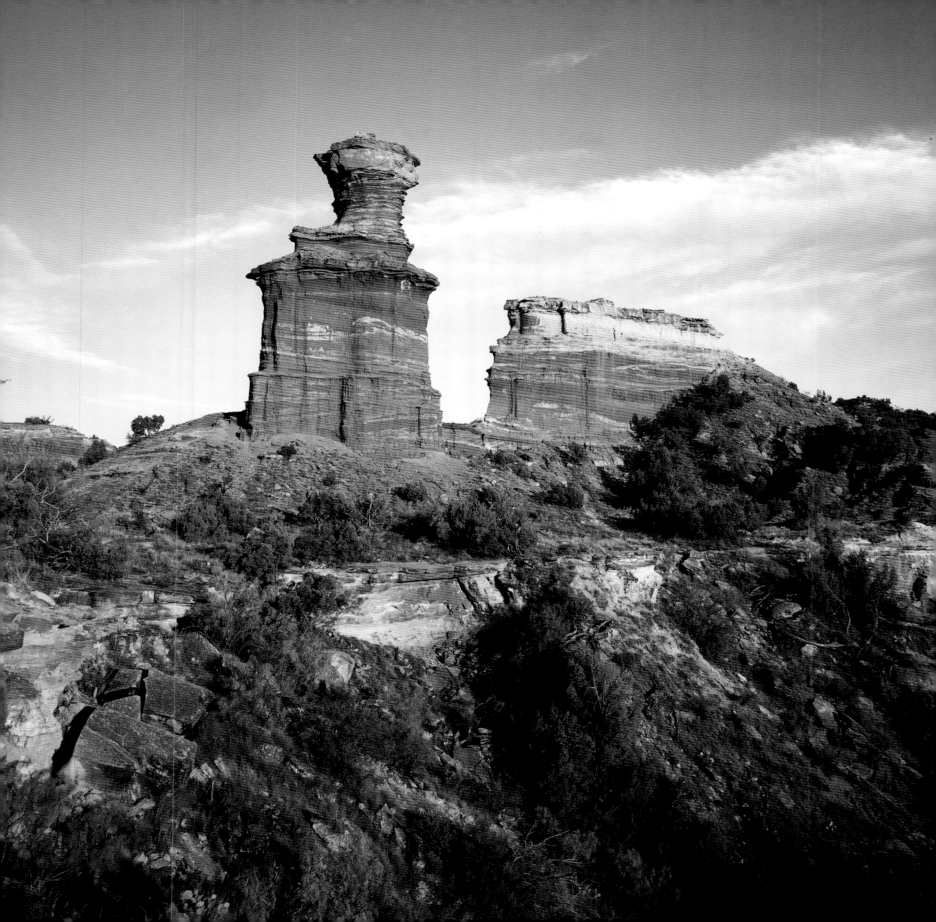

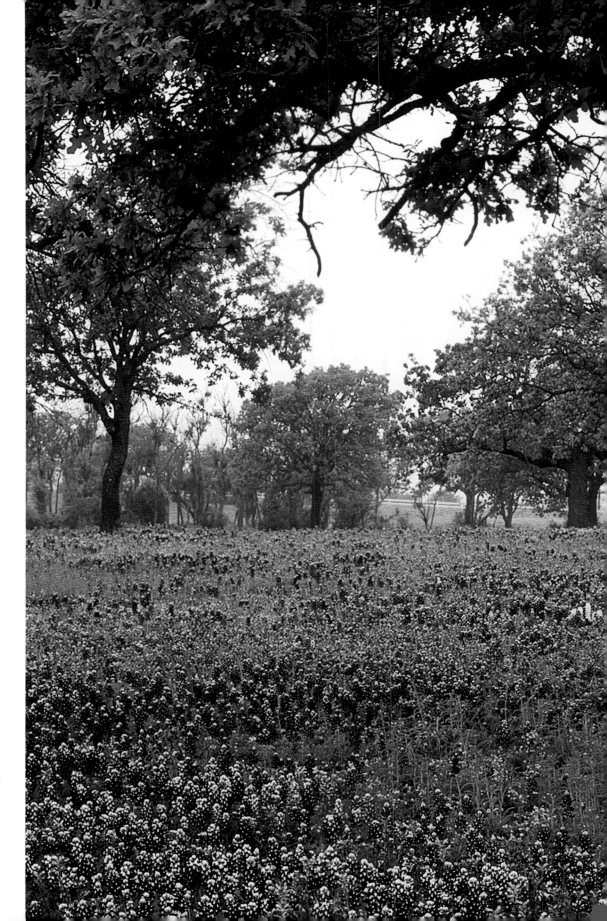

To experience the magnificent wildflowers that cover the Texas landscape in the spring, is to step into a beautiful painting. Soft pastels and brilliant reds and oranges spread out for miles on the exquisite canvas of rural Texas.

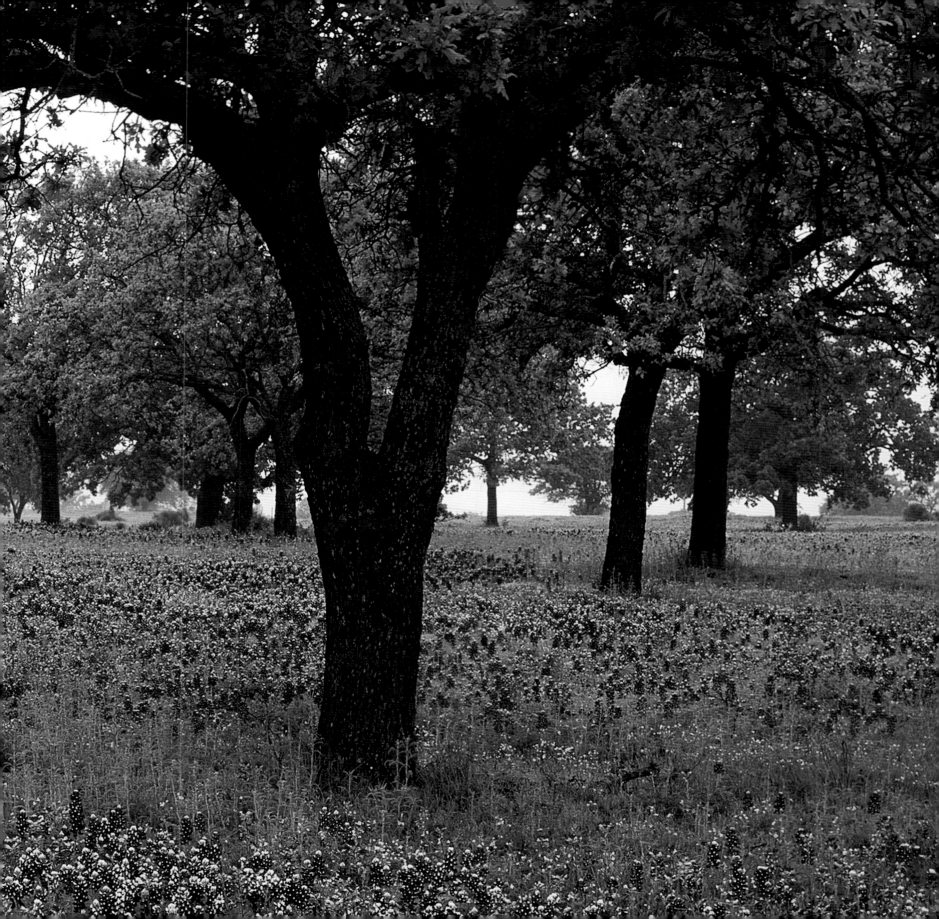

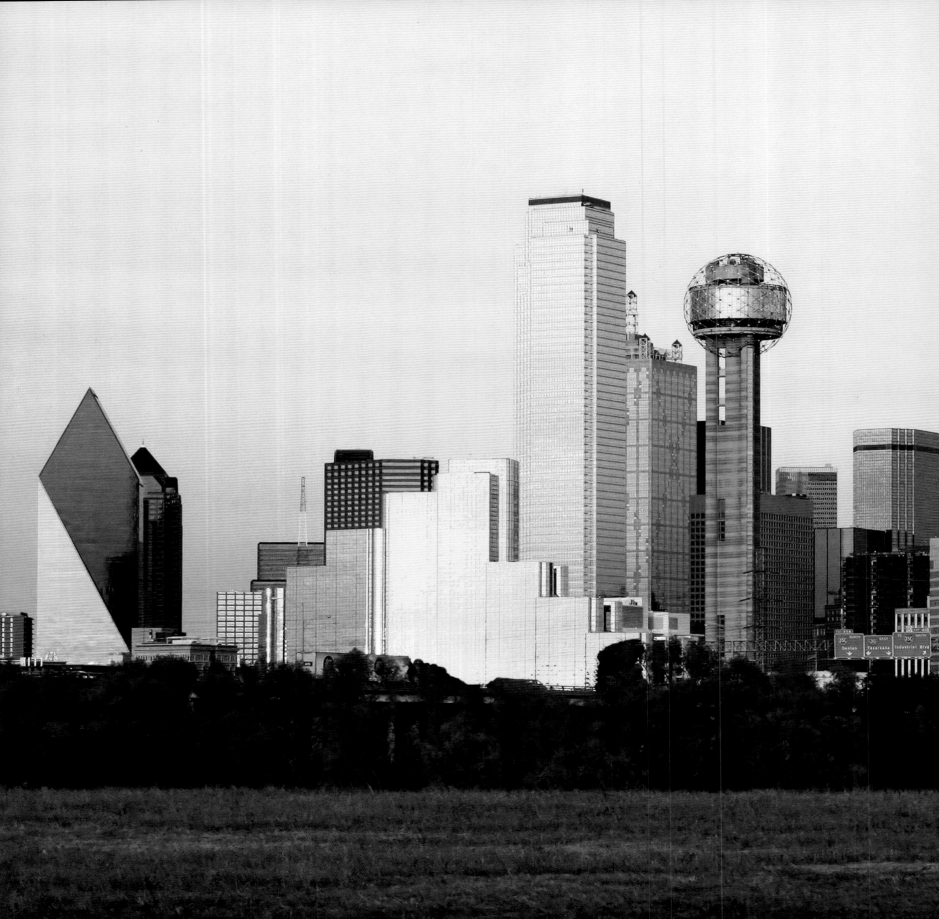

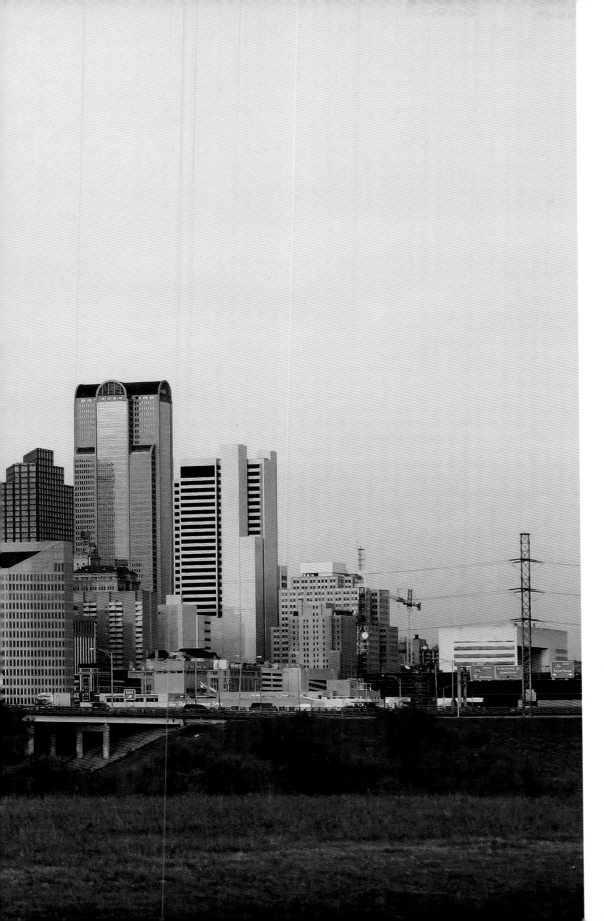

Affectionately known by its citizens as "Big D," Dallas is a leading commercial and financial center and the country's ninth largest city. It is known for its daring contemporary architecture, but it is also proud of its beautifully restored historic districts.

This simple, concrete memorial to President John F. Kennedy dominates a square in downtown Dallas, just 200 yards from where the president was assassinated on November 22, 1963. According to the architect, Philip Johnson, it is intended to be *"not a memorial to the pain and sorrow of death,"* but *"a permanent tribute to the joy and excitement of one man's life."*

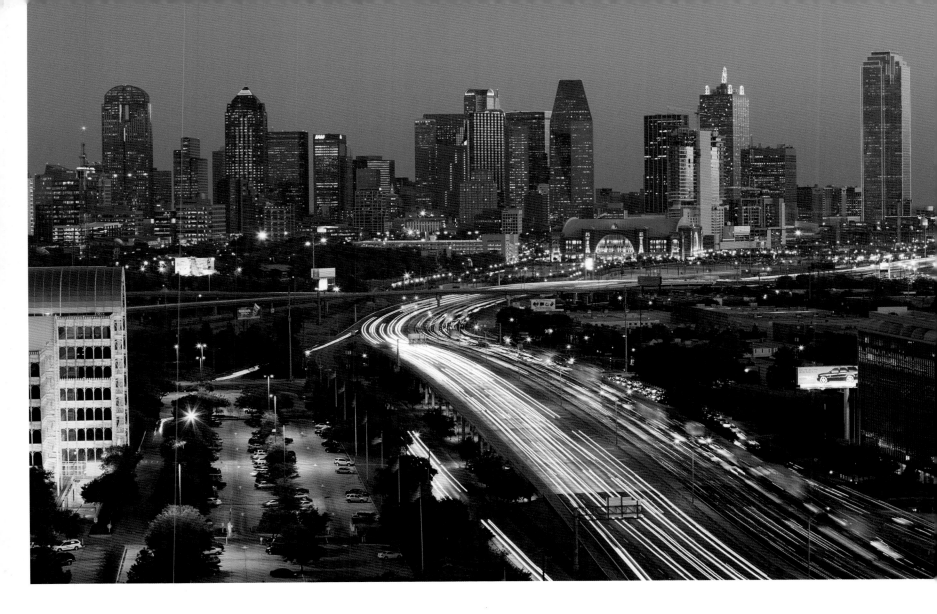

Dallas shows its dynamic sparkle in the evening skyline as the traffic rushes along the Stemmons Freeway north of downtown and east of the Trinity River. Not only a convention city and banking center, Dallas also has a thriving night life and music scene.

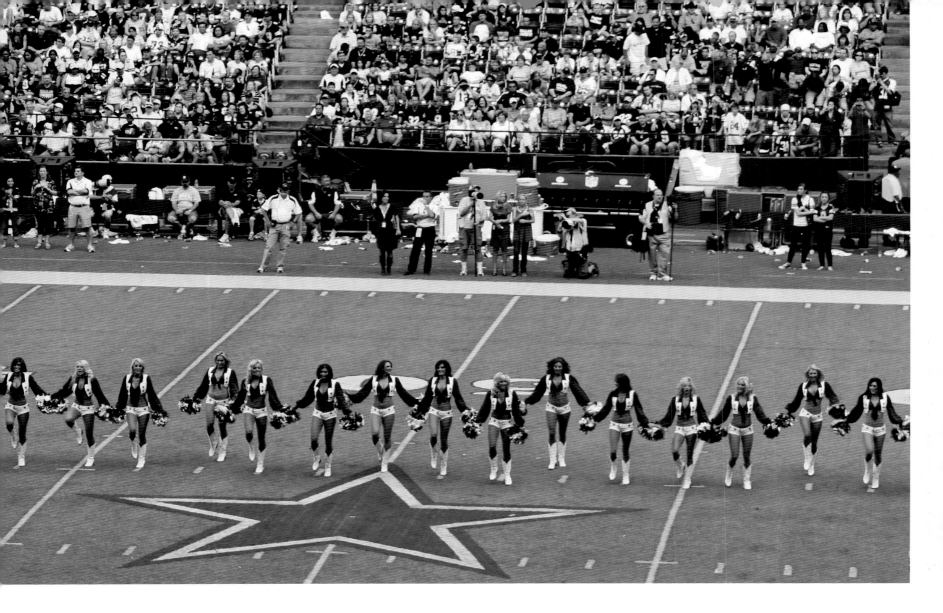

The world-renowned Dallas Cowboy Cheerleaders are an American icon, combining beauty and athleticism as they cheer "America's Team" on to victory. Their precision dance routines require stamina, flexibility and timing, but they make it look easy as they flash those brilliant Texan smiles. These American Sweethearts earned the first USO's prestigious Spirit of Hope award. They continue to be the drop-dead gorgeous ambassadors of sportsmanship and community service around the globe.

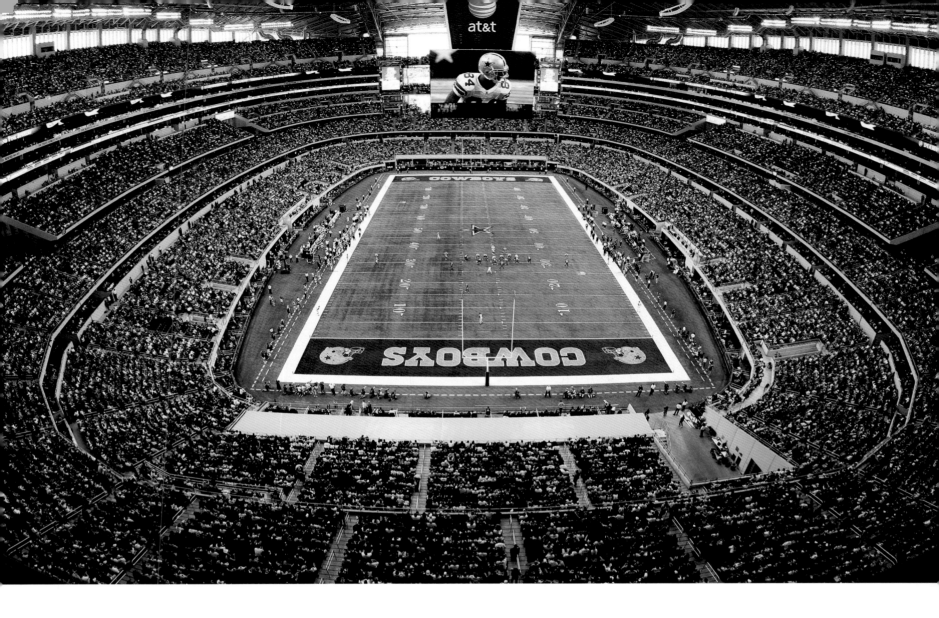

The Dallas Cowboys, Super Bowl Champions many times over, now play in the sensational Cowboys Stadium in Arlington. The stadium seats 80,000 and is the largest domed stadium in the world. It boasts the world's largest column-free interior with the largest high-definition video screen.

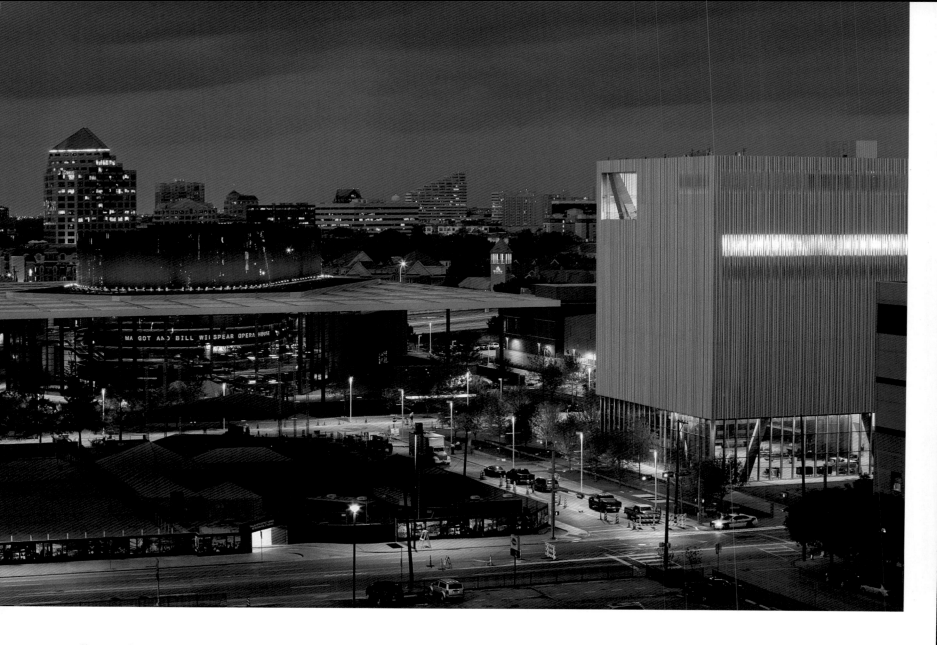

Dallas combines a lively cultural scene with innovative architecture, as evidenced by the 12-level Dee and the Charles Wyly Theatre *(above right)* and the Margot and Bill Winspear Opera House *(above left)*. The opera house offers state-of-the-art performance spaces for the Dallas Opera and the Texas Ballet Theater. Its Margaret McDermott Performance Hall *(opposite page)* has a grand presence that is enhanced by 1,400 deep-red glass panels.

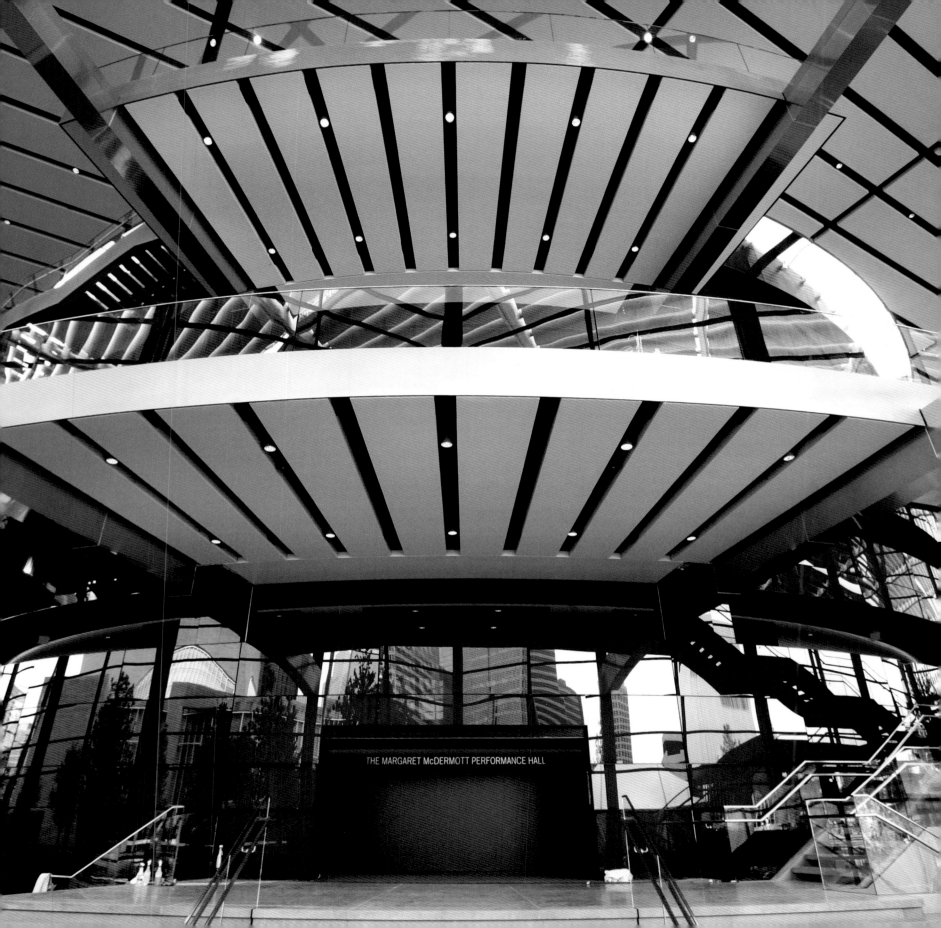

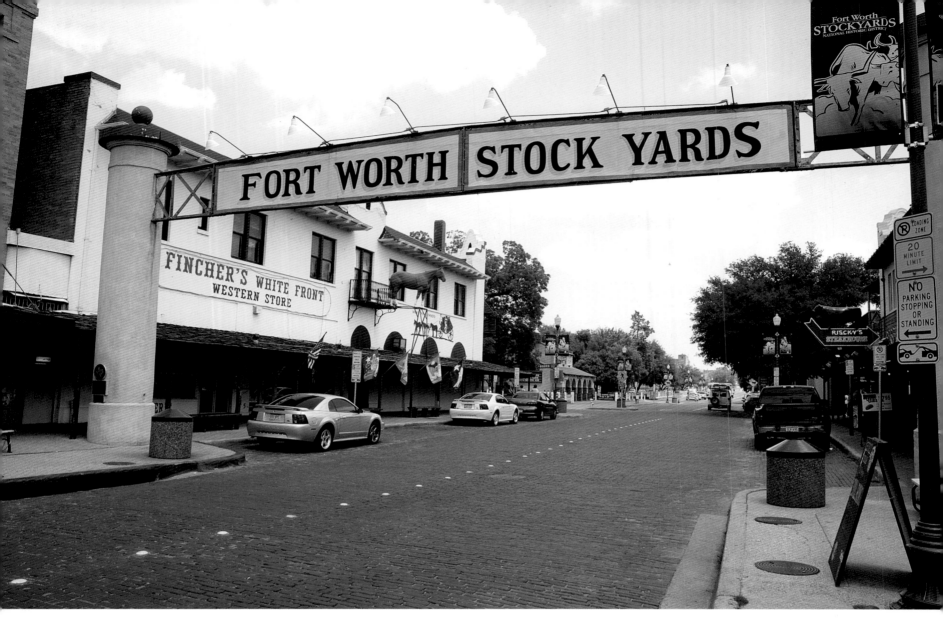

Nicknamed *Cowtown* because of its frontier status as the major center for the great Texas cattle drives, Fort Worth has developed into a sophisticated center renowned for excellent museums.

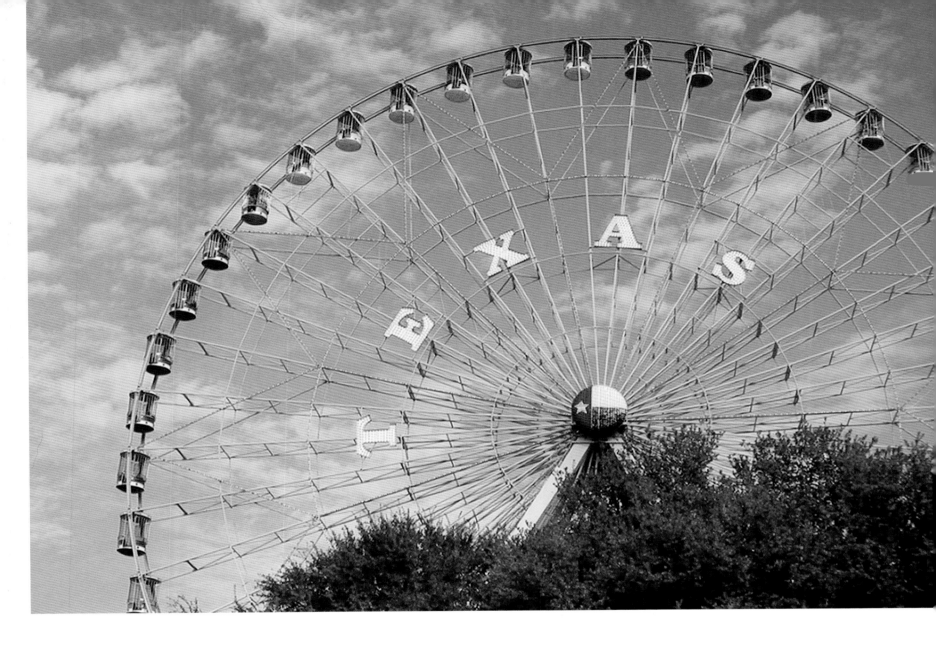

Texans and tourists love fun in a big way, and the state's sunny blue skies make it ideal for carnivals and fairs. The Texas Star is the biggest Ferris wheel in the country. It operates during the State Fair of Texas – the biggest state fair in the country, of course – held each year in Dallas.

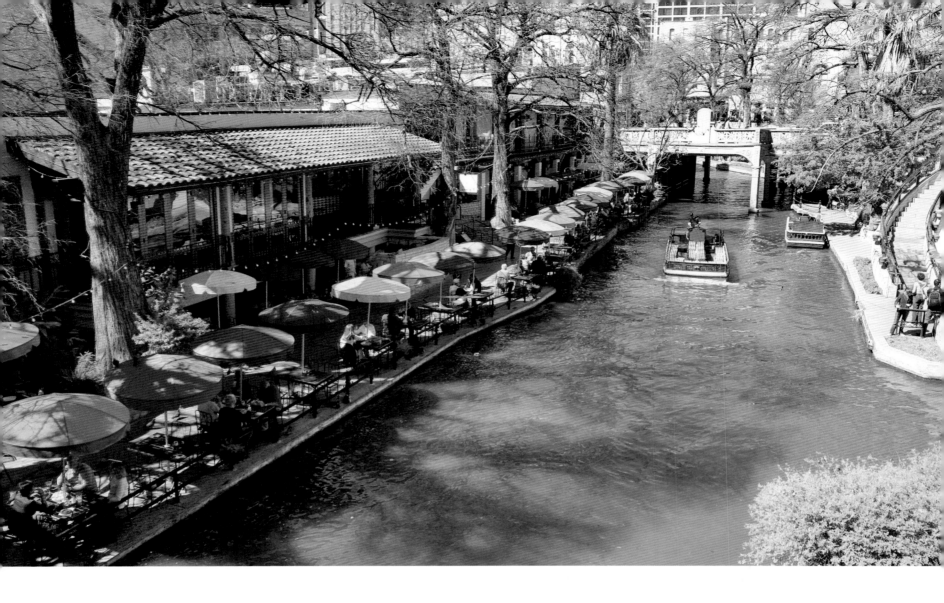

San Antonio's 2.5-mile River Walk, or *Paseo del Rio*, is a charming, tree-lined area of galleries, craft shops and sidewalk cafés. The reflections of the landscaped riverbanks sparkle on the San Antonio River as it meanders through the heart of this glorious and captivating city.

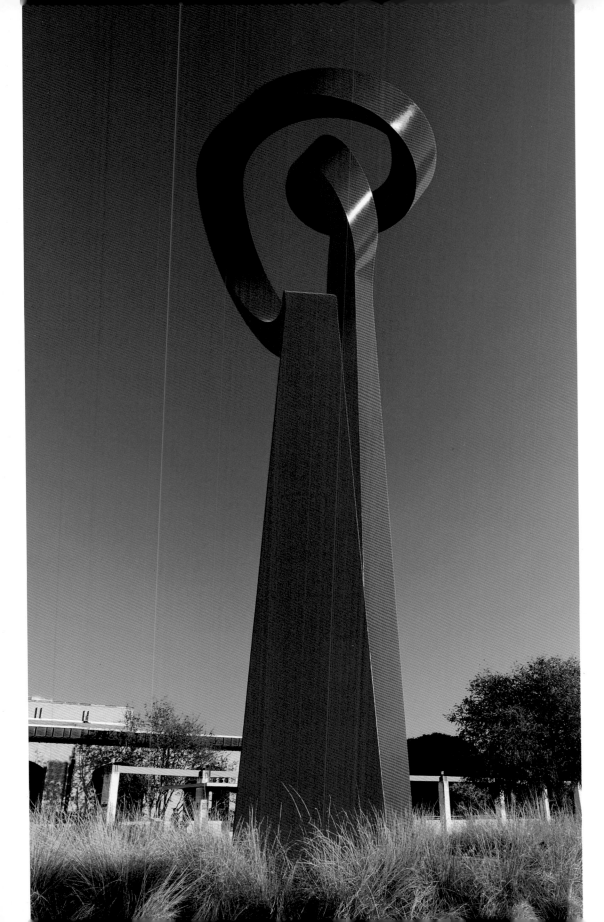

The Torch of Friendship was given to San Antonio by the Mexican Consulate in 2002 as a sign of friendship to commemorate the peaceful relationship between the United States and Mexico. The contemporary steel sculpture is the work of the Mexican artist Sebastian. It stands 65 feet tall and weighs 50 tons.

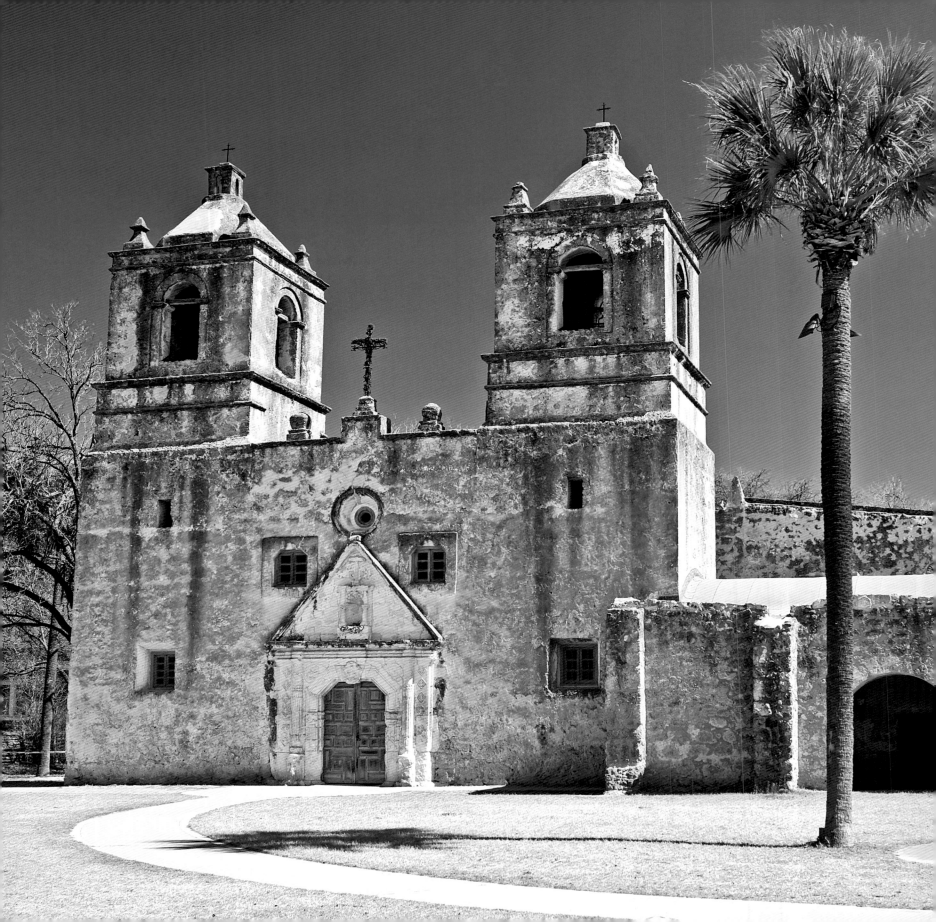

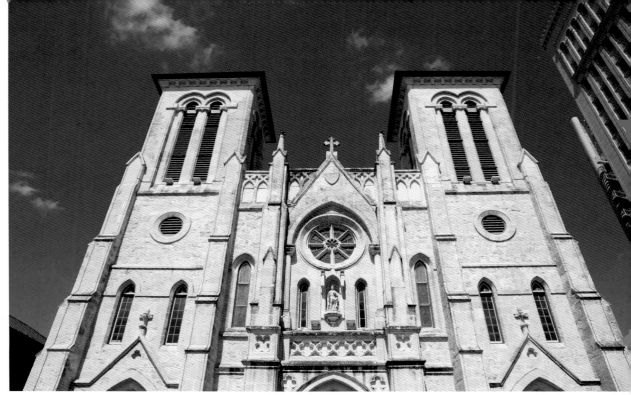

ABOVE: As early as 1731, builders sent by King Philip of Spain started work on the magnificent San Fernando Cathedral in San Antonio. It is the oldest church building in Texas and has the distinction of functioning as a center of unity and harmony for all religious denominations. In the mid-1800s, the original structure was transformed into an imposing Gothic Revival building.

LEFT: Mission Nuestra Señora de la Purísima Concepción de Acuña was originally established in East Texas in 1716 to serve the Ainais Indians. In 1730 the mission moved to present-day Austin before moving to San Antonio in 1731. The massive stone church is the oldest unrestored church in the United States and is renowned for its great acoustics.

The Cathedral of San Agustin, established in 1778, is located in the historical heart of the downtown area of Laredo. The present building dates from 1872. In 2000, the Diocese of Laredo was established and the San Agustin Church was made its cathedral by orders of His Holiness Pope John Paul II.

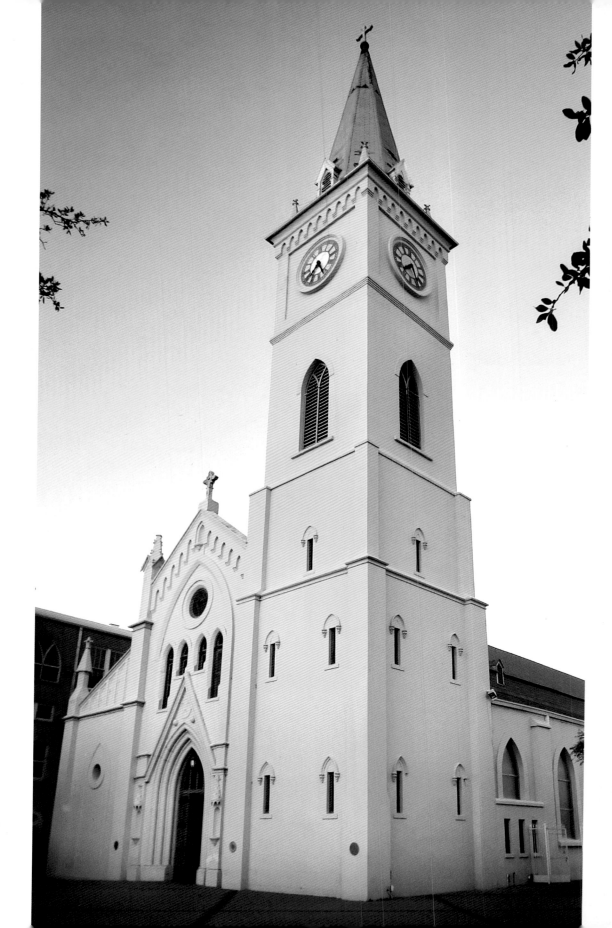

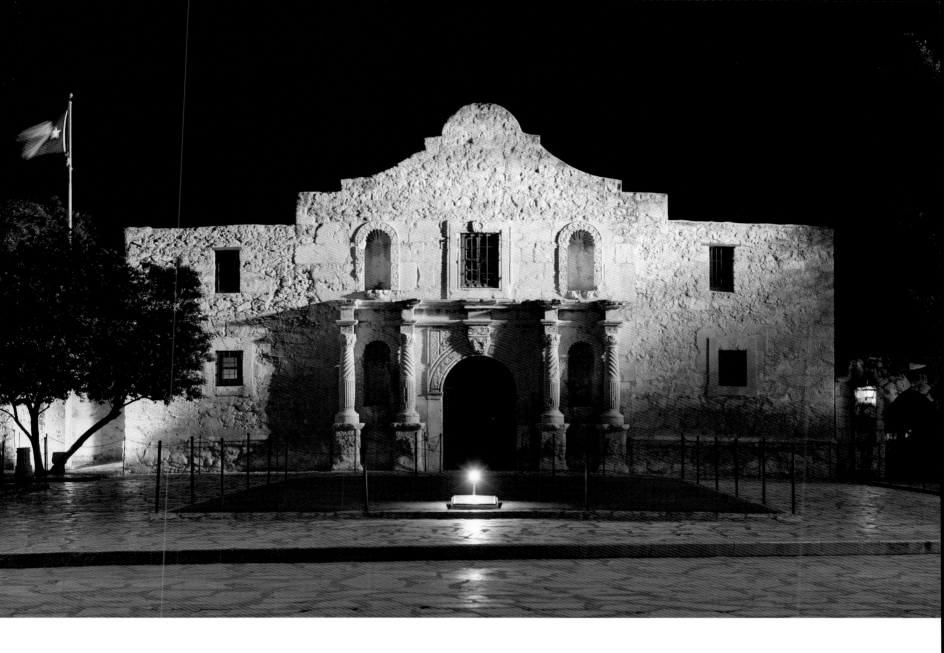

The Alamo stands as a glorious testament to the courage of the heroic defenders of Texas independence. In 1836, the struggle was tragically lost at this famous mission, but then soon regained at San Jacinto with the famous battle cry "Remember the Alamo." People worldwide recognize the Alamo as a symbol of a heroic struggle against impossible odds – a place where men made the ultimate sacrifice for freedom.

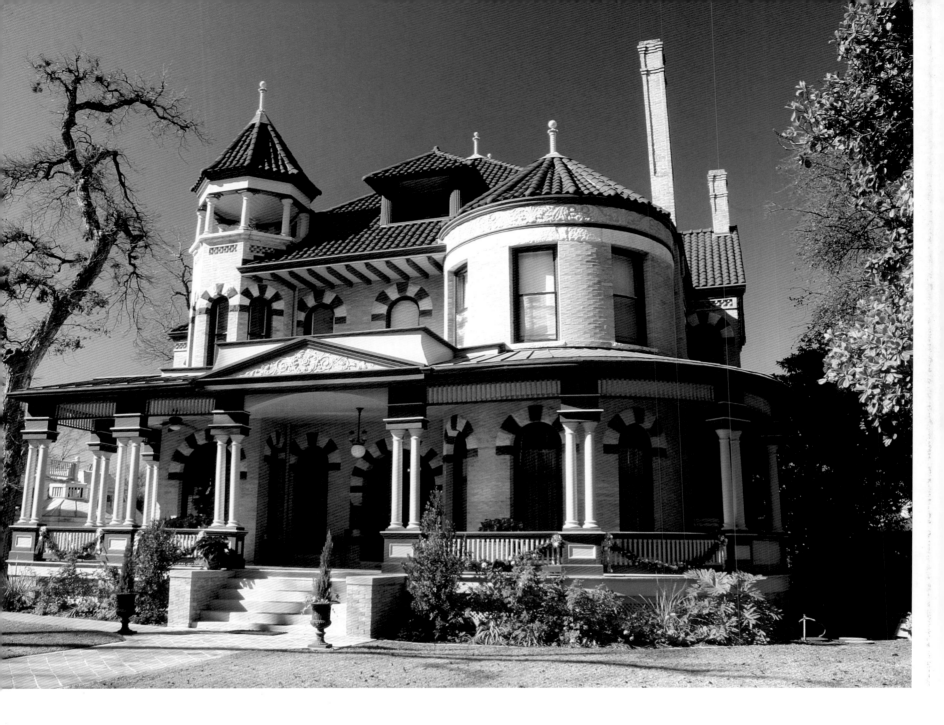

Some of the most beautiful mansions in the state are found in San Antonio's King William historic district, named for King Wilhelm I of Prussia. In the late 1800s, German merchants built these grand Victorian residences, which are shaded by enormous pecan and cypress trees.

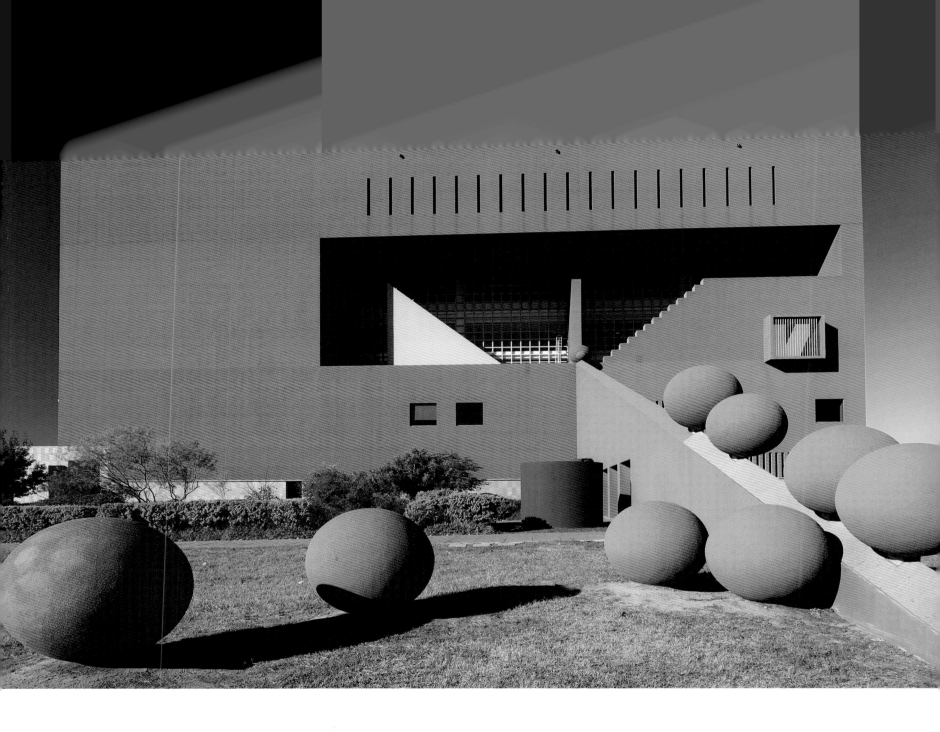

The Central Library is a 240,000-square-foot, six-story structure in downtown San Antonio that opened in 1995. The building is easily recognized by its bright-colored, striking Mexican modernist design. The primary color of the building's exterior is "enchilada red."

TEXAS – PHOTO CREDITS

CORBIS
Walter Babikow/JAI 81; Reinhard Eisele 50; Tom Fox/Dallas Morning News 84, 85; Danny Lehman 53; Richard T. Nowitz 80; Brad Schloss/Icon SMI 83; Aaron M. Sprecher/Icon SMI 51.

SHUTTERSTOCK
All cover images, 3 (top), 3 (middle), 3 (bottom), 4, 6, 8, 9, 10, 12, 13, 15, 16, 18, 19, 20, 21, 22, 24, 25, 26, 27, 28, 29, 30, 31, 32, 34, 35, 36, 37, 38, 39, 40, 41, 42, 44, 45, 46, 47, 48, 49, 52, 54, 55, 56, 57, 58, 59, 62, 64, 65, 66, 67, 68, 69, 70, 72, 73, 74, 75, 76, 78, 82, 86, 87, 88, 89, 90, 91, 92, 94, 95.